Russian Girls

HOT SEXY RUSSIAN LINGERIE GIRLS MODELS PICTURES

By **EROTICA PHOTO ART LOVER**

Copyright © Russian Girls

ALL RIGHTS RESERVED. NO PART OF THIS DOCUMENT MAY BE REPRODUCED OR TRANSMITTED IN ANY FORM OR BY ANY MEANS, ELECTRONIC, MECHANICAL, PHOTOCOPYING, RECORDING, OR OTHERWISE, WITHOUT PRIOR WRITTEN PERMISSION OF EROTICA PHOTO ART LOVER.

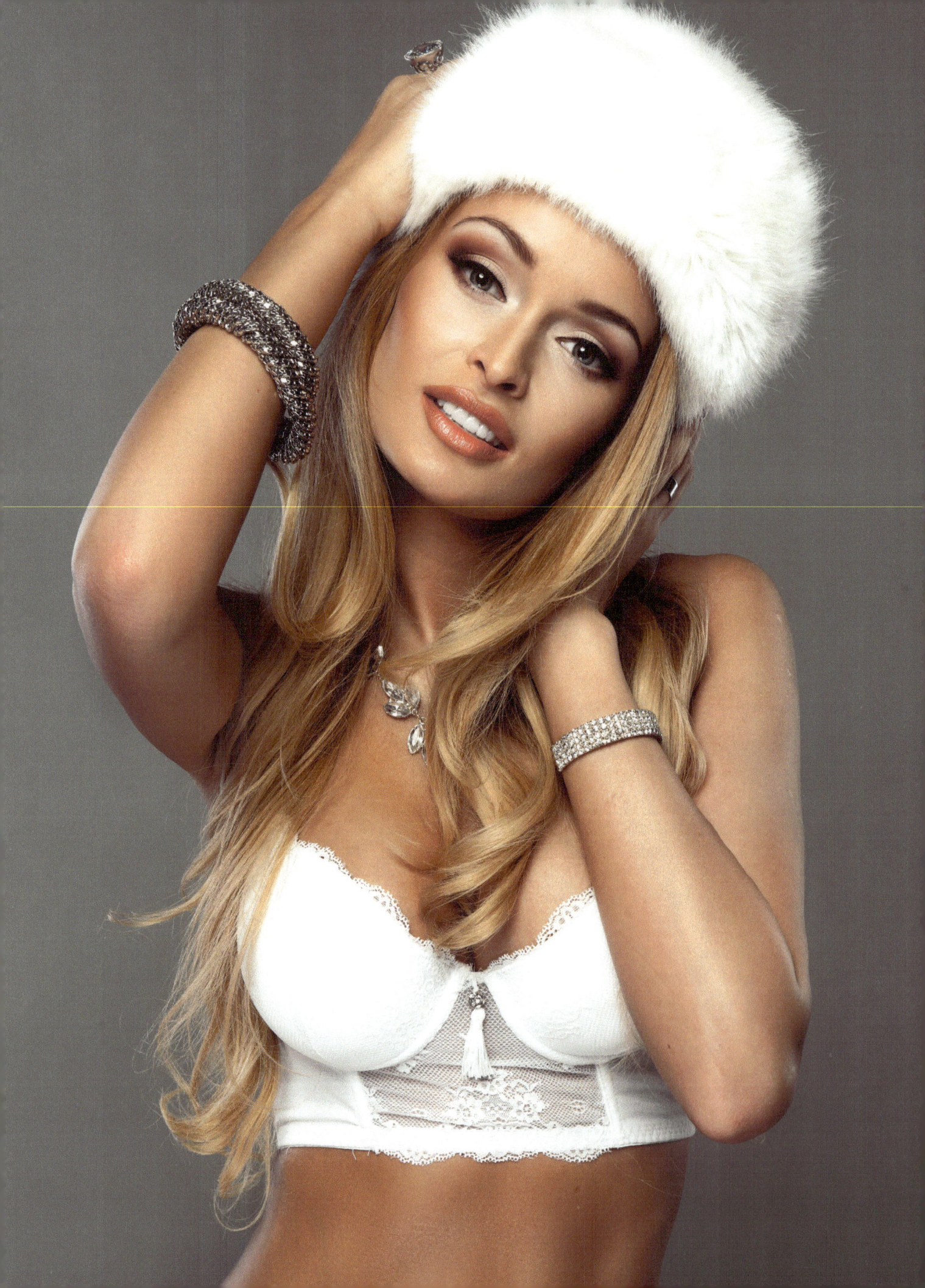

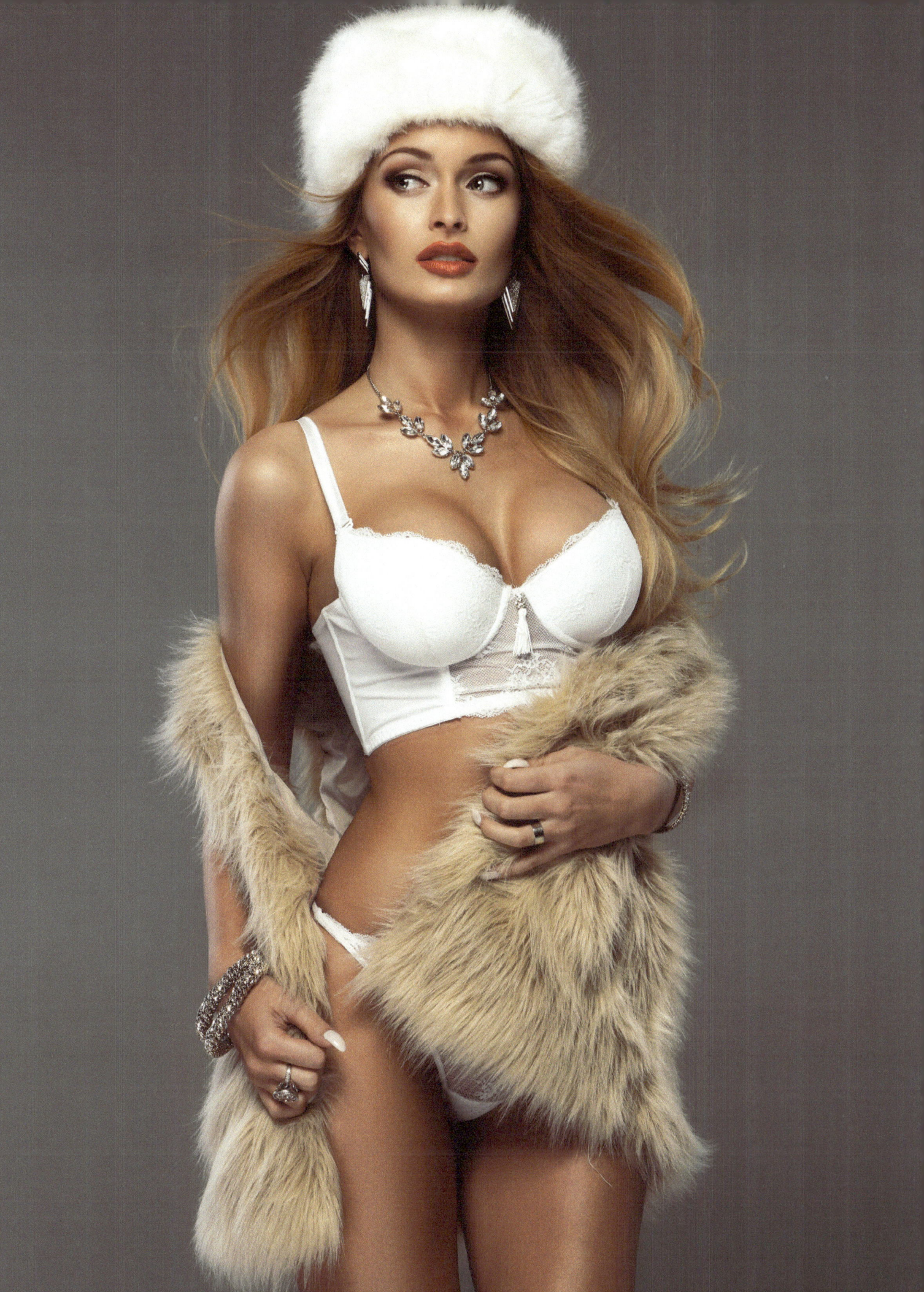

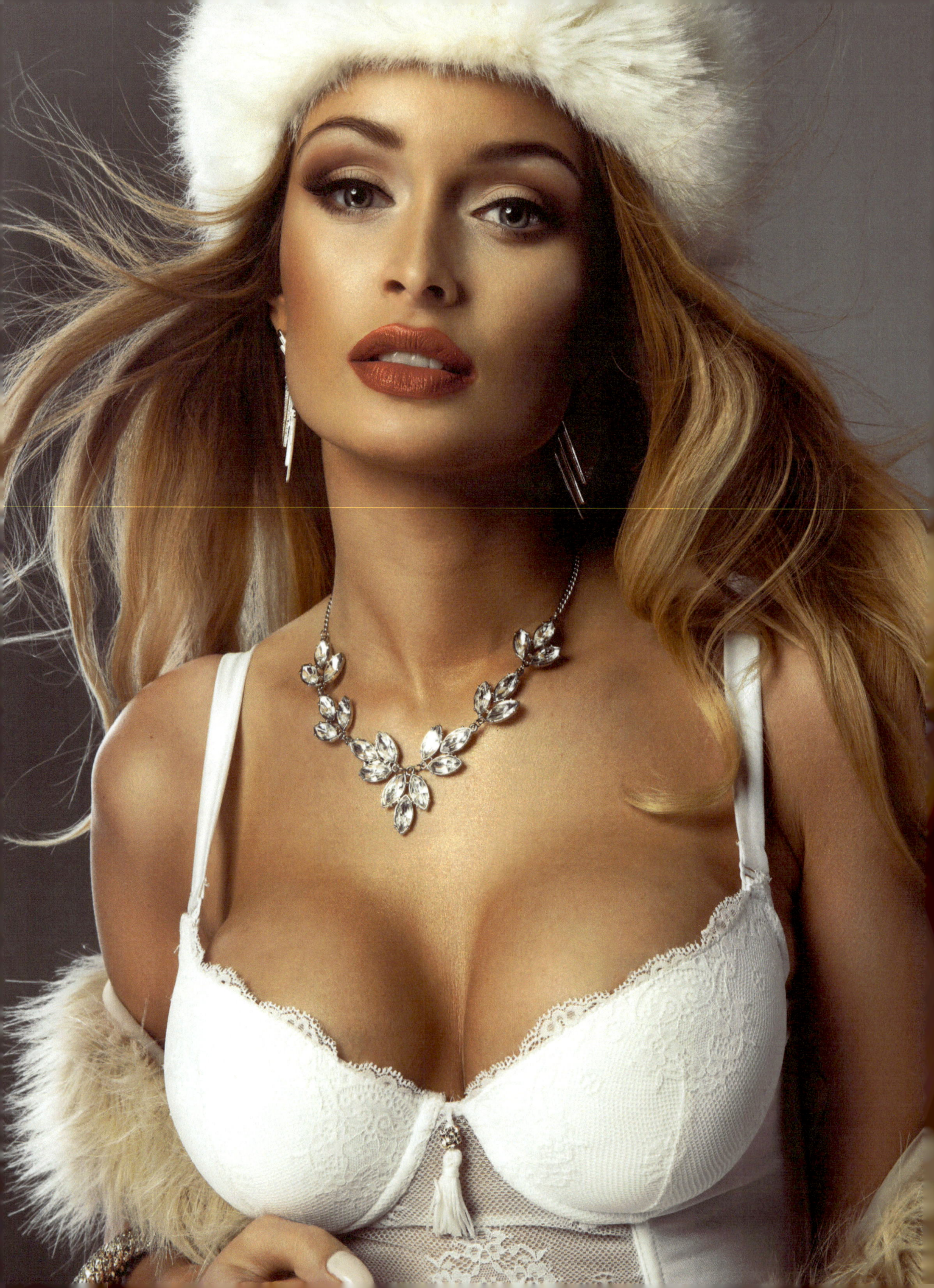

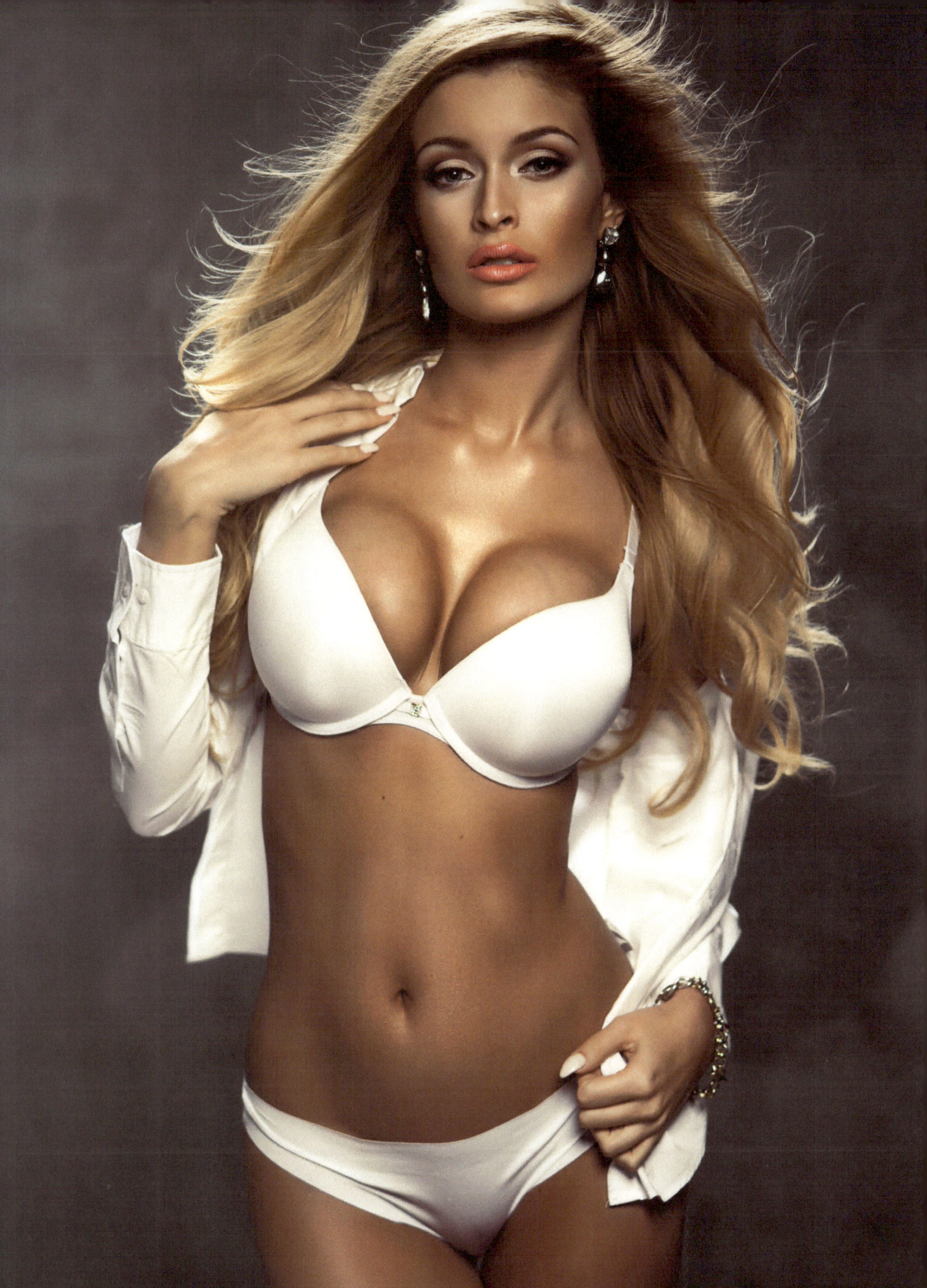

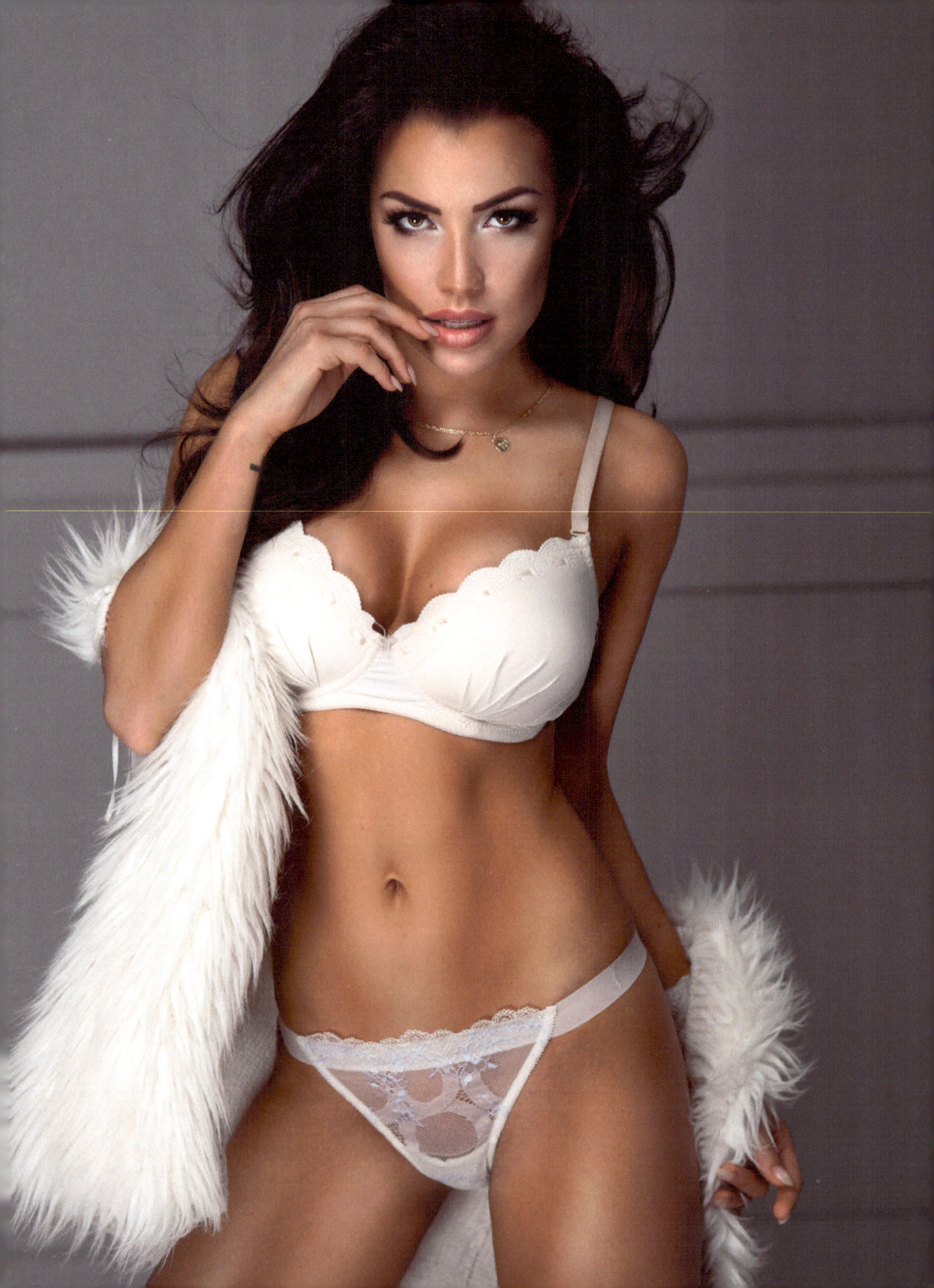

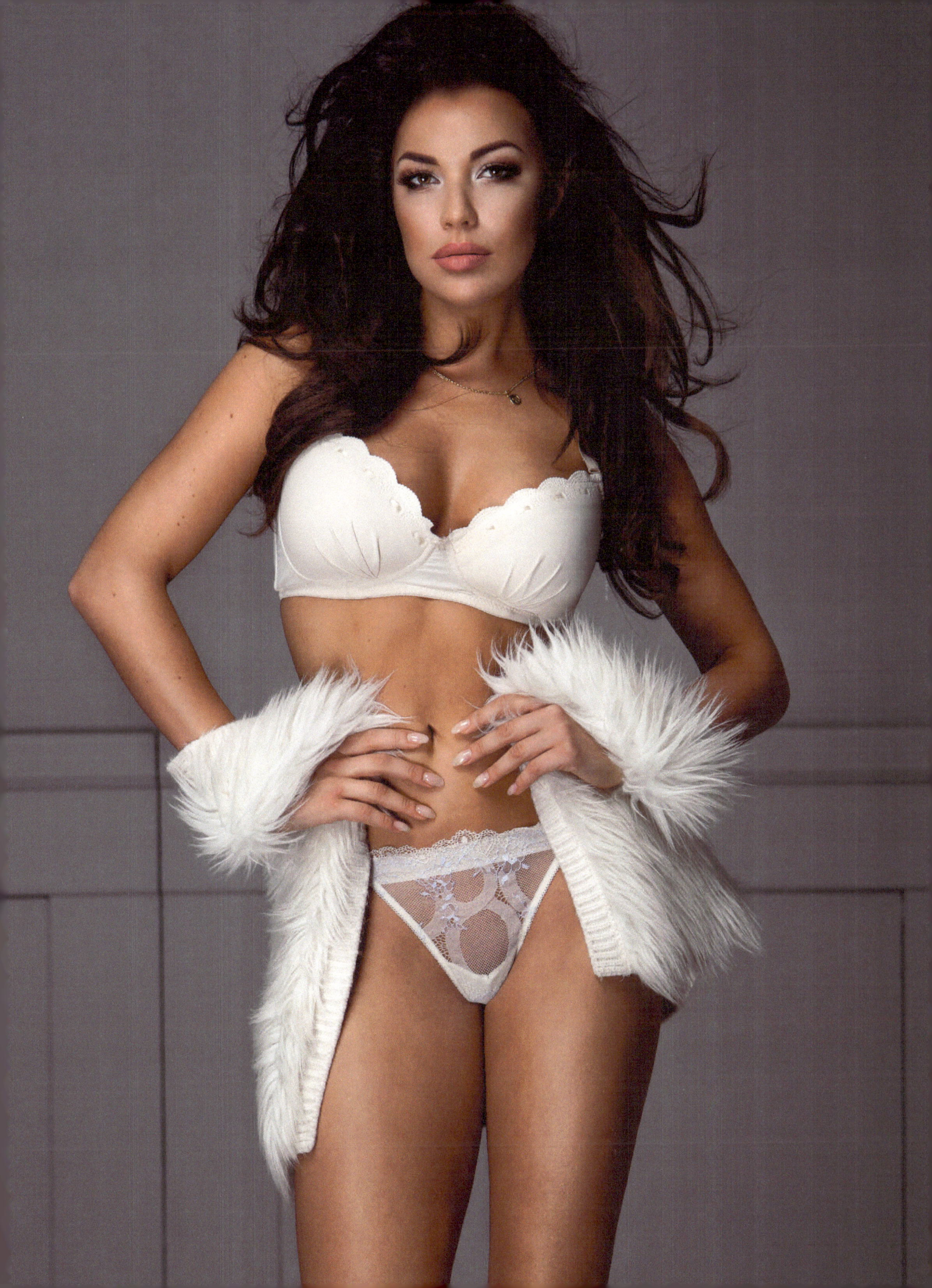

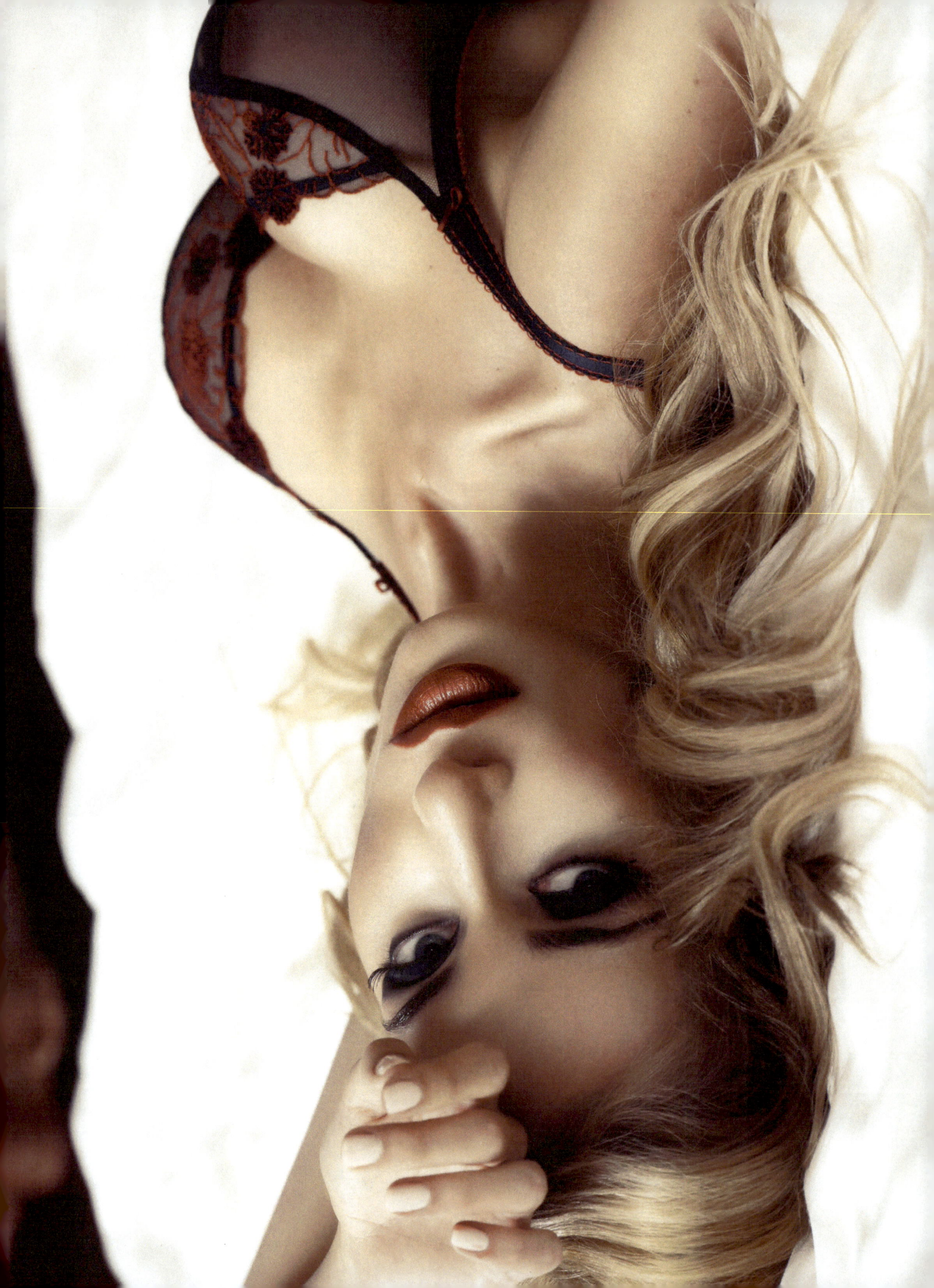

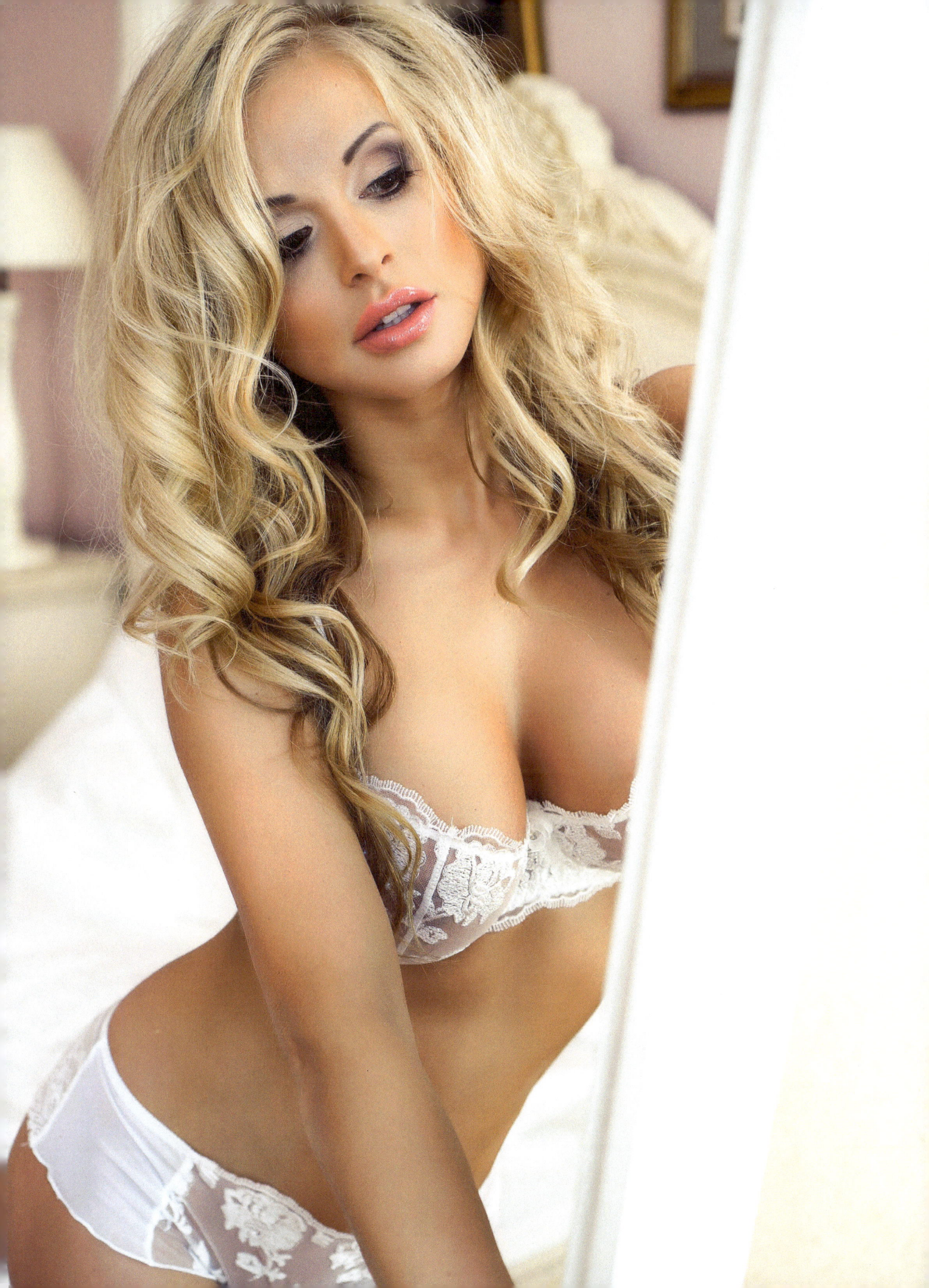

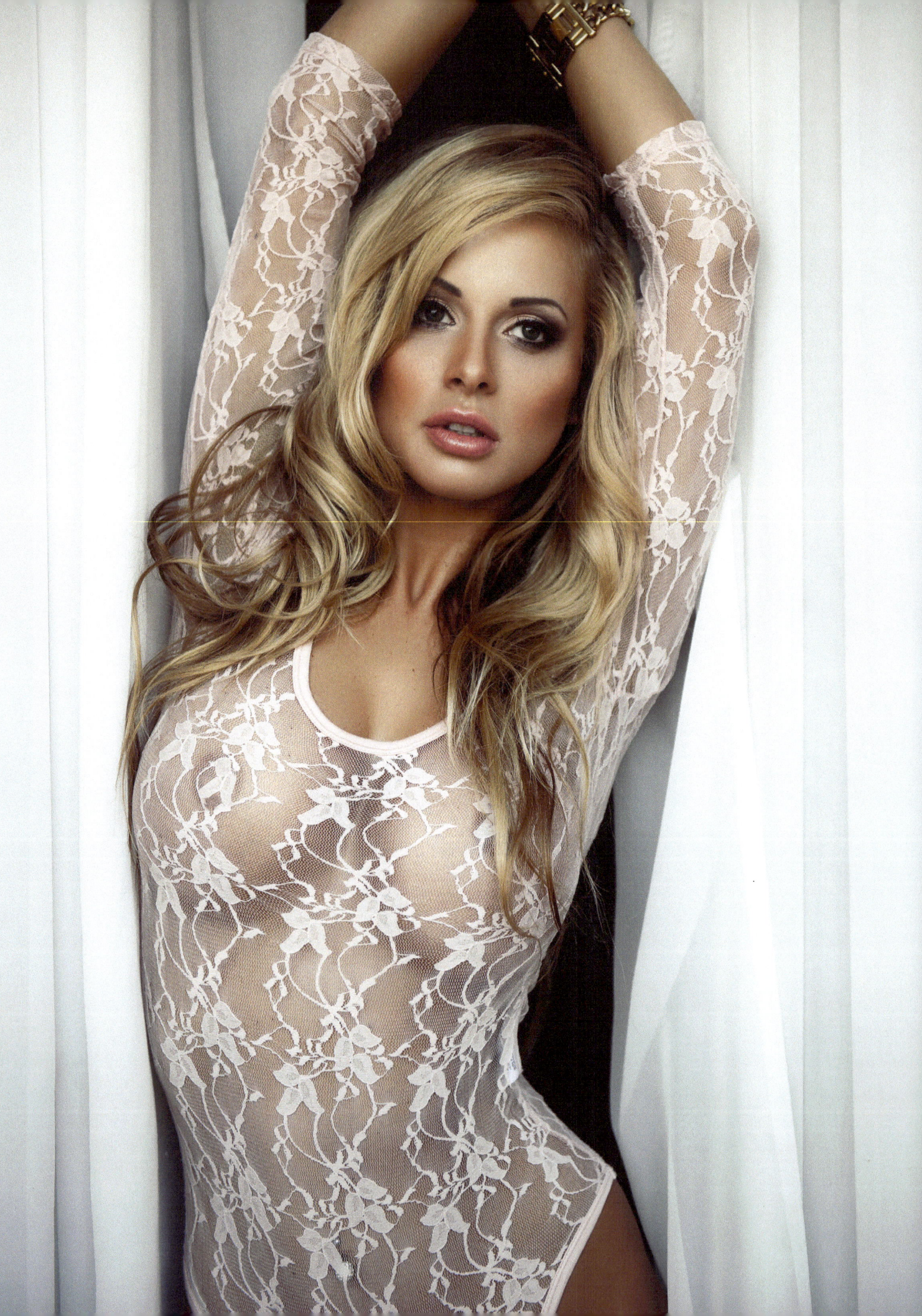

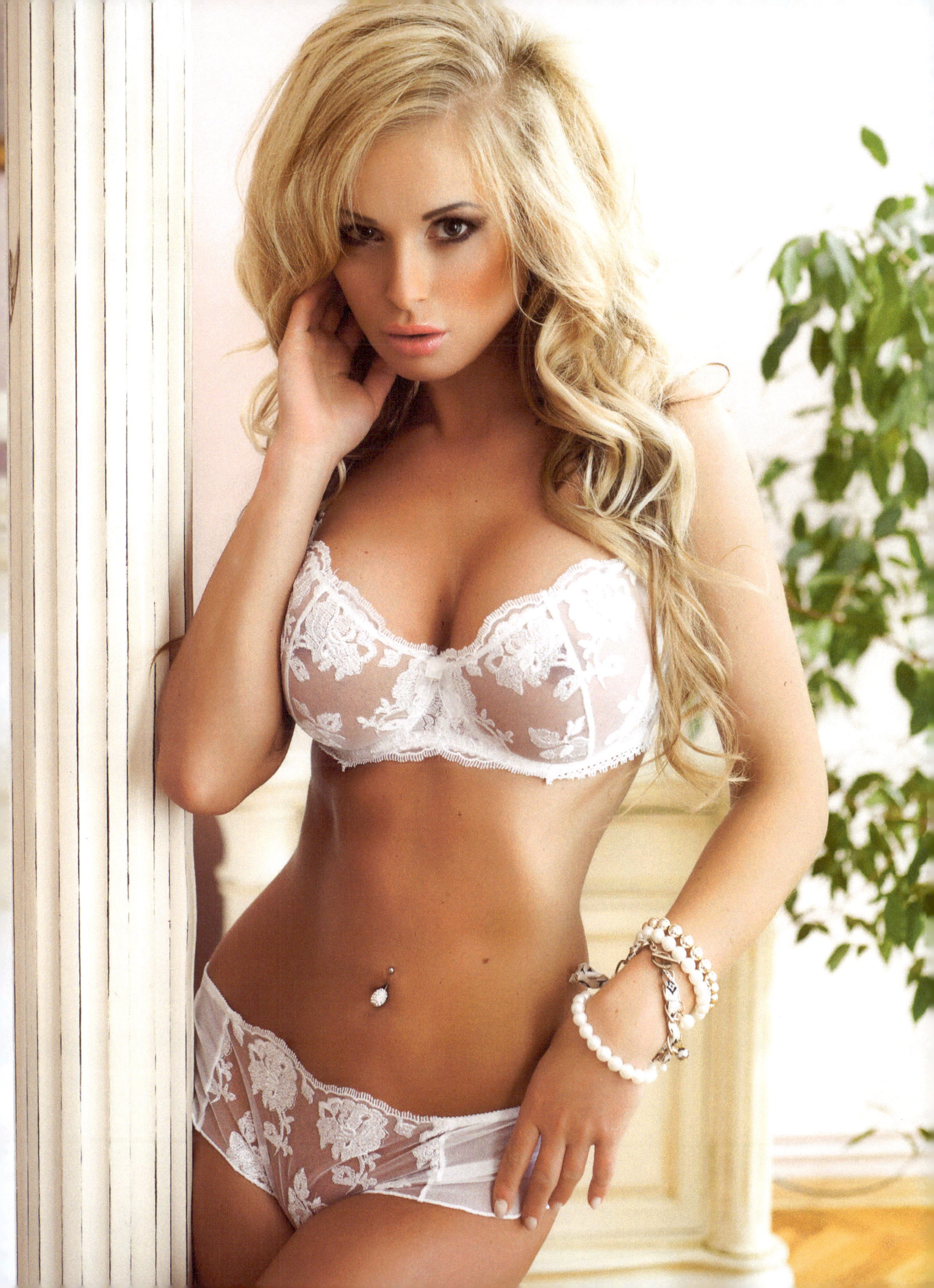

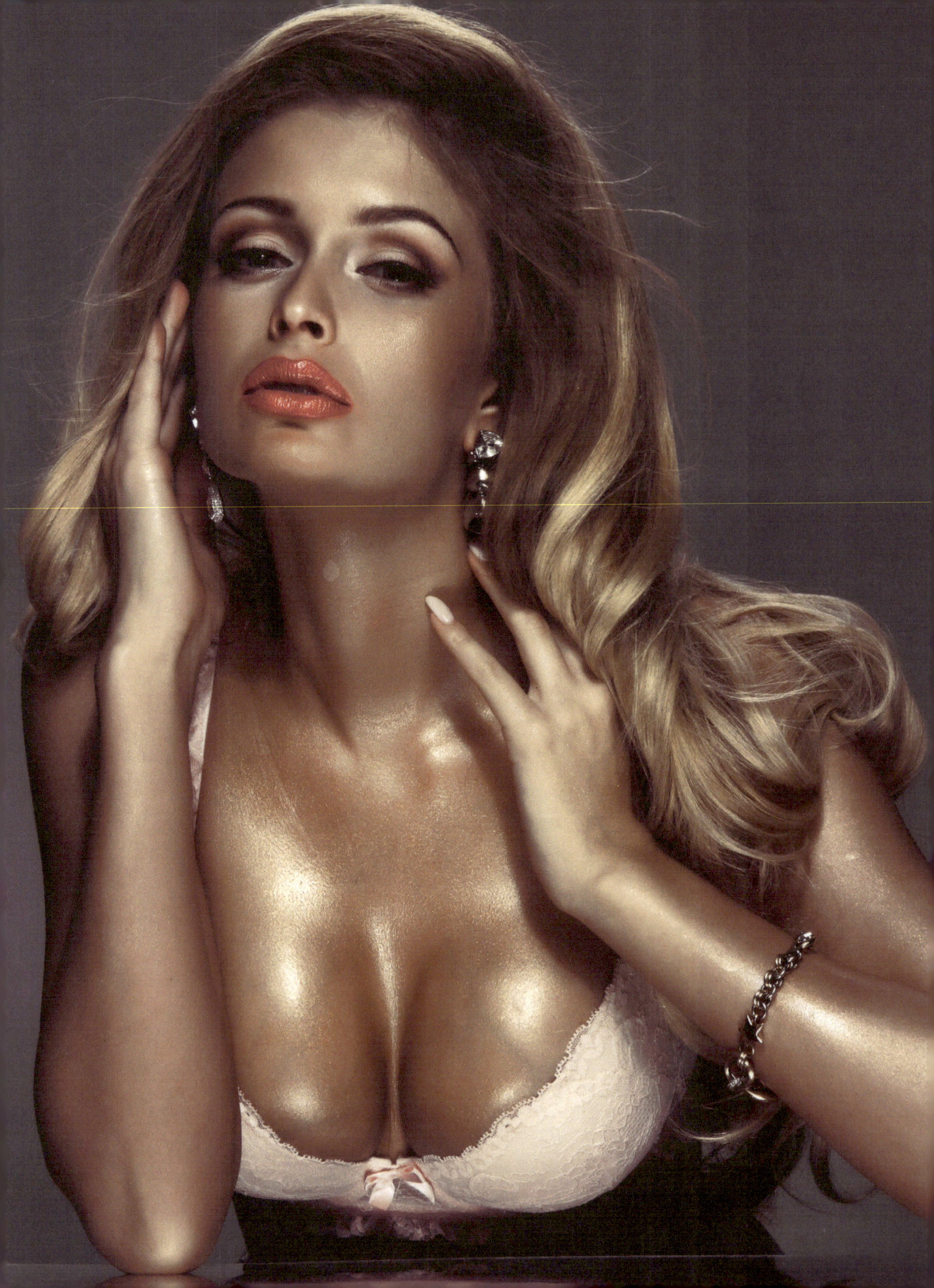

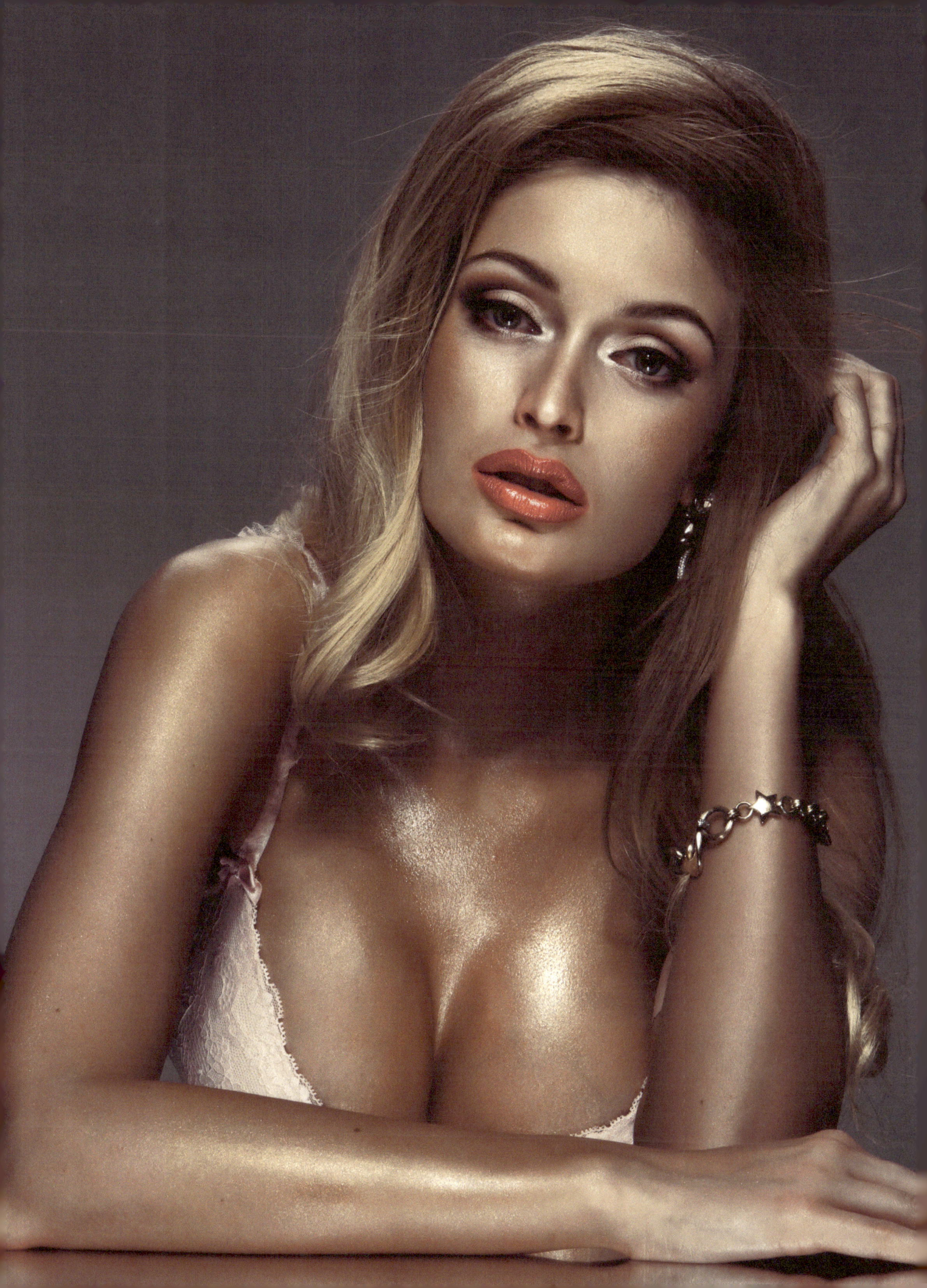

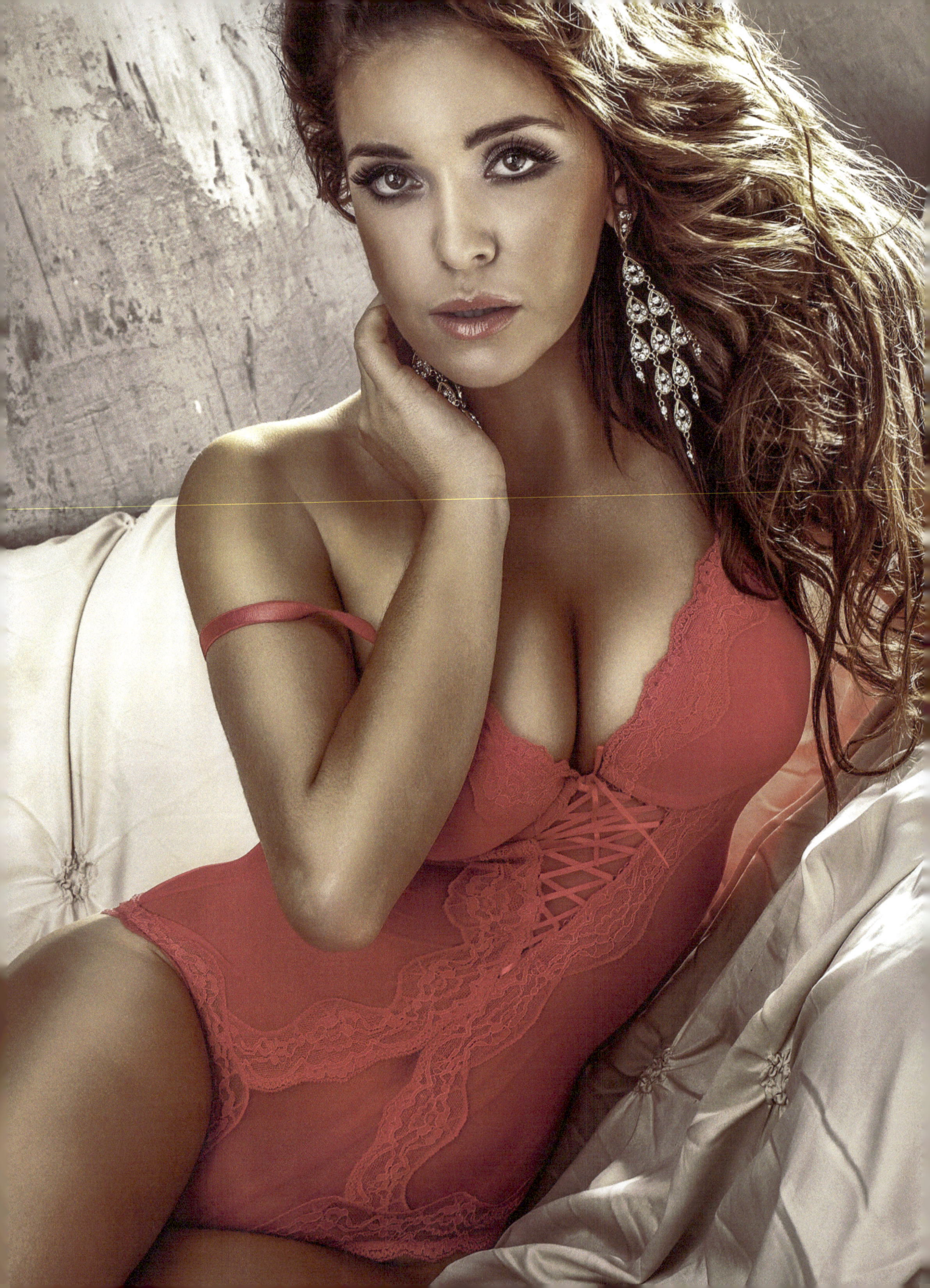

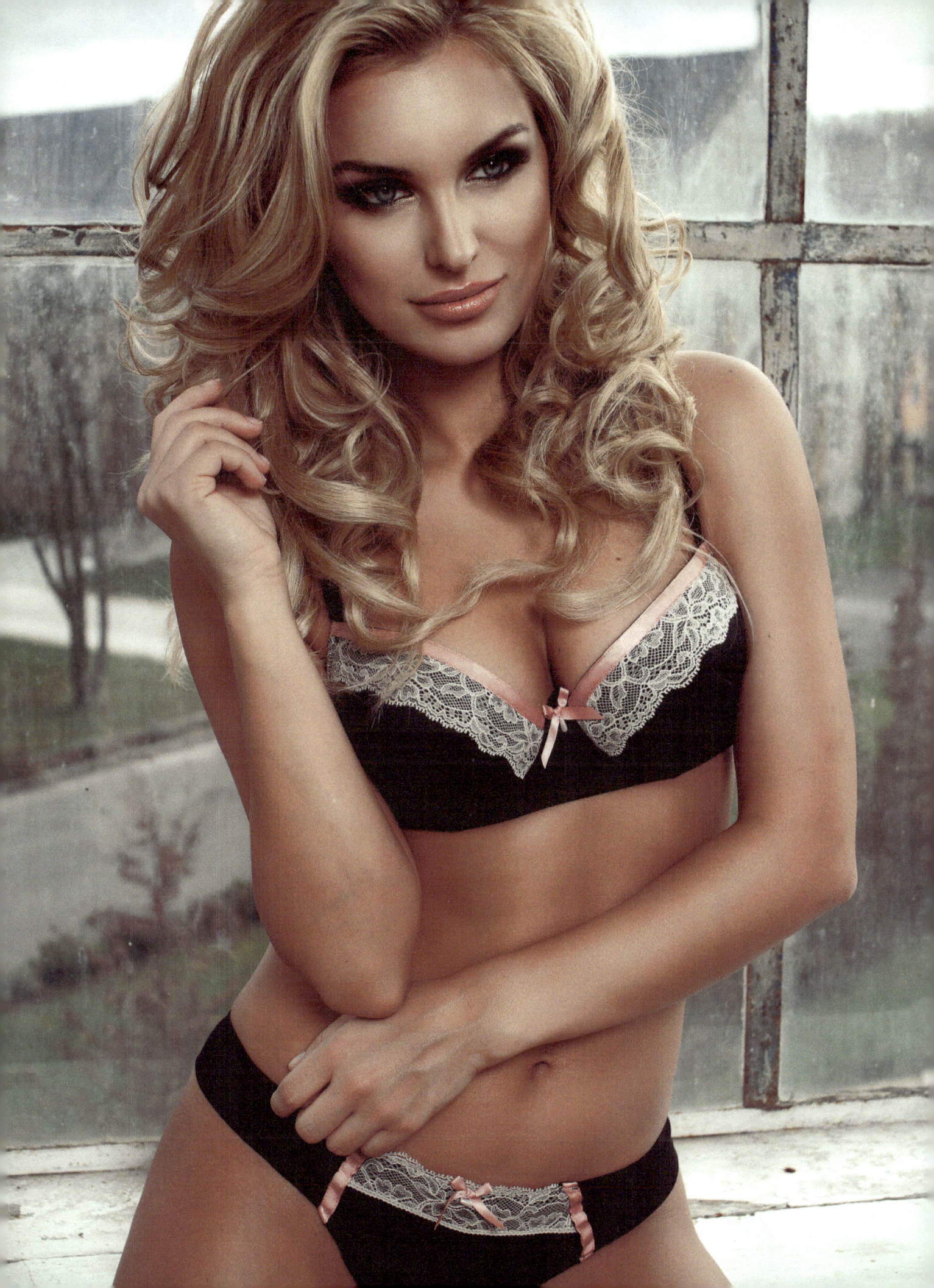

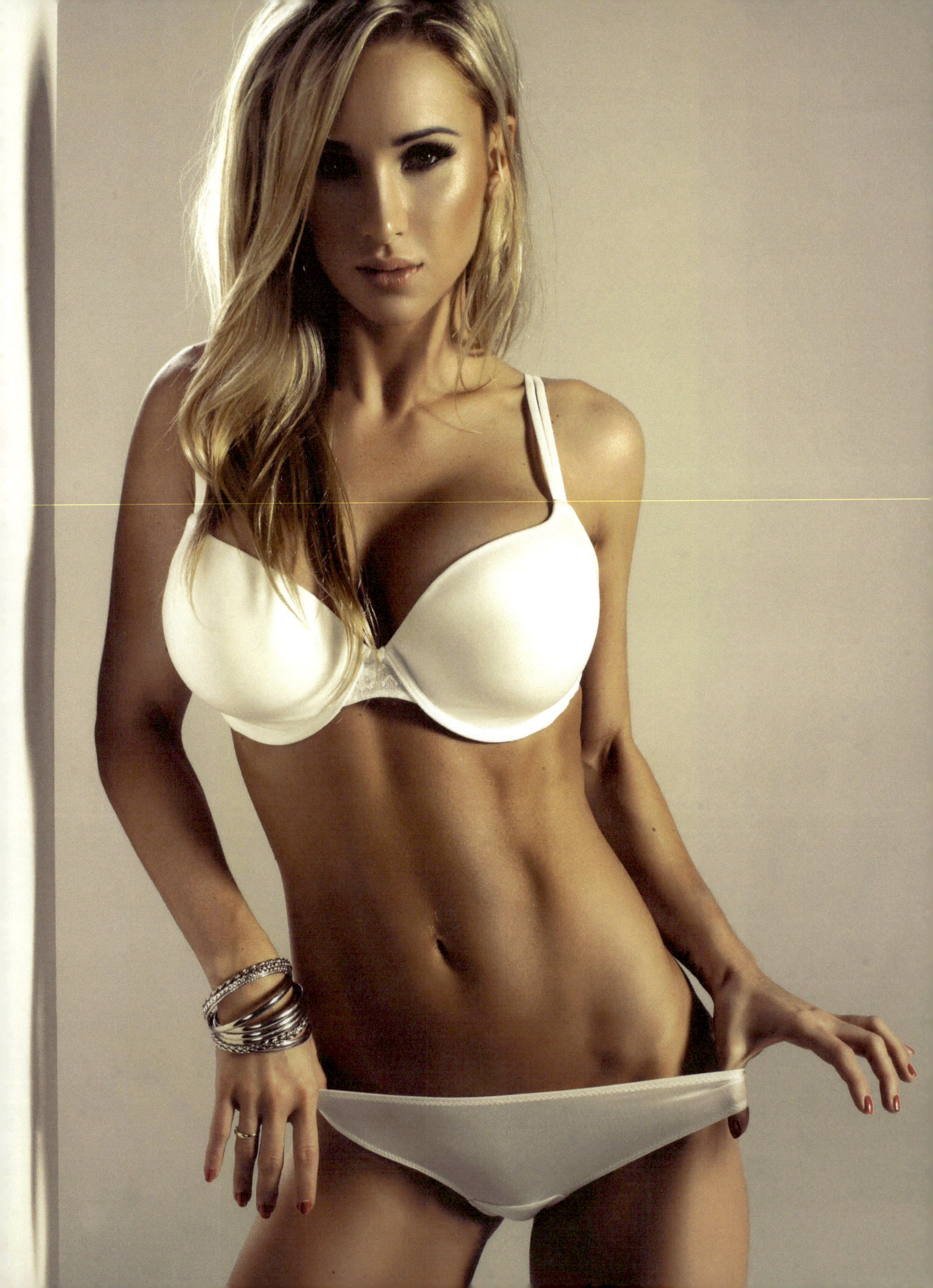

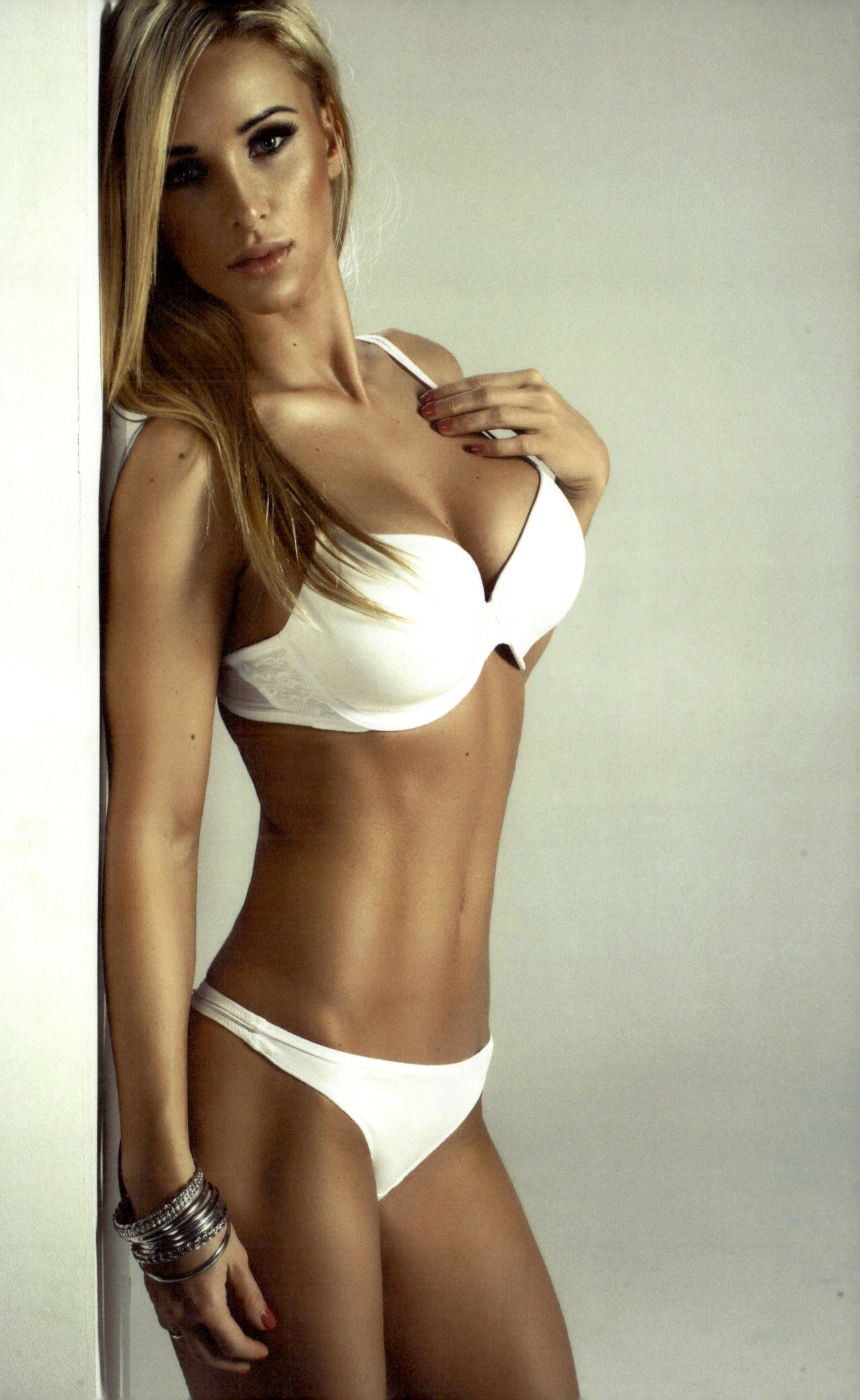

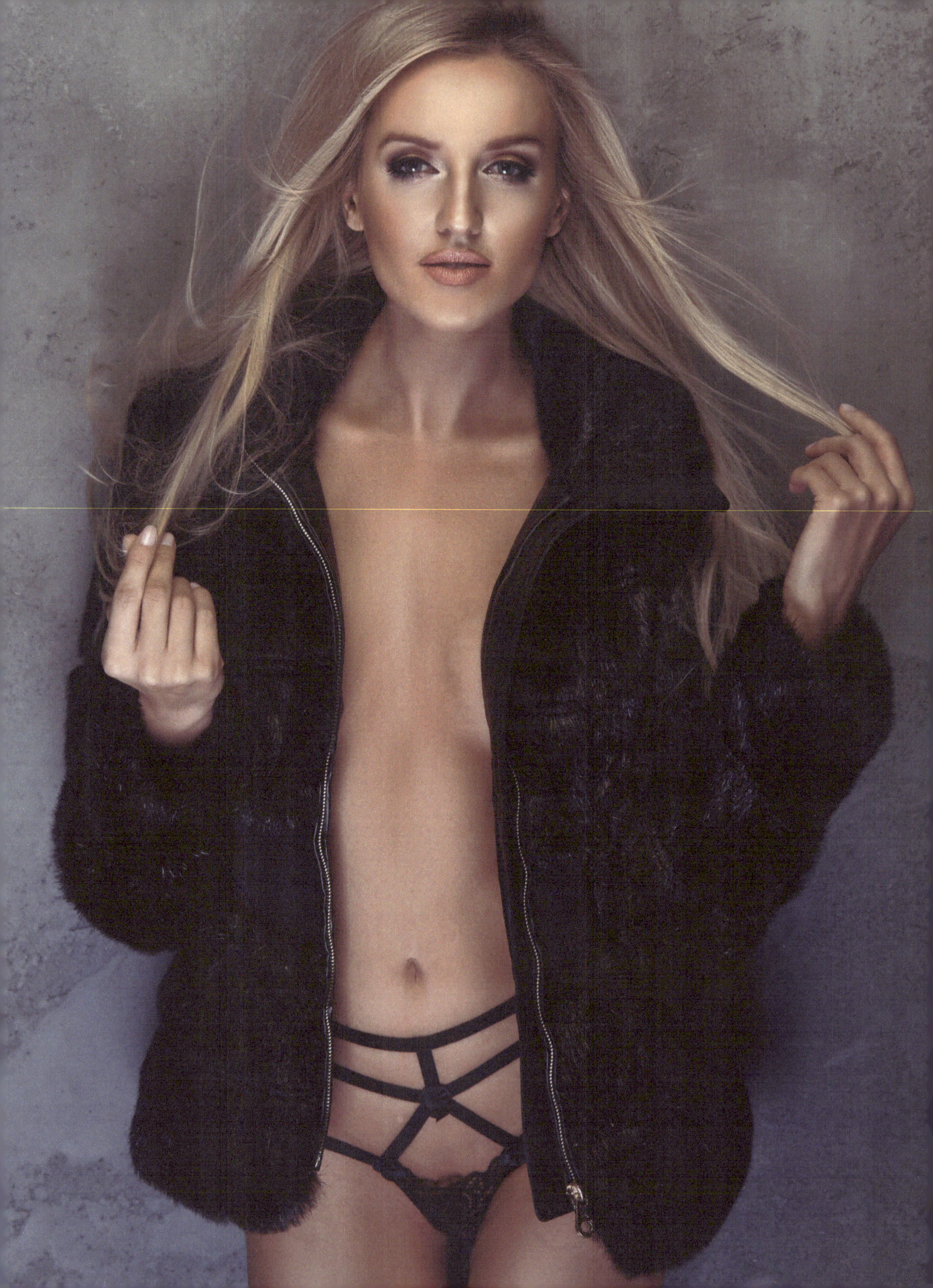

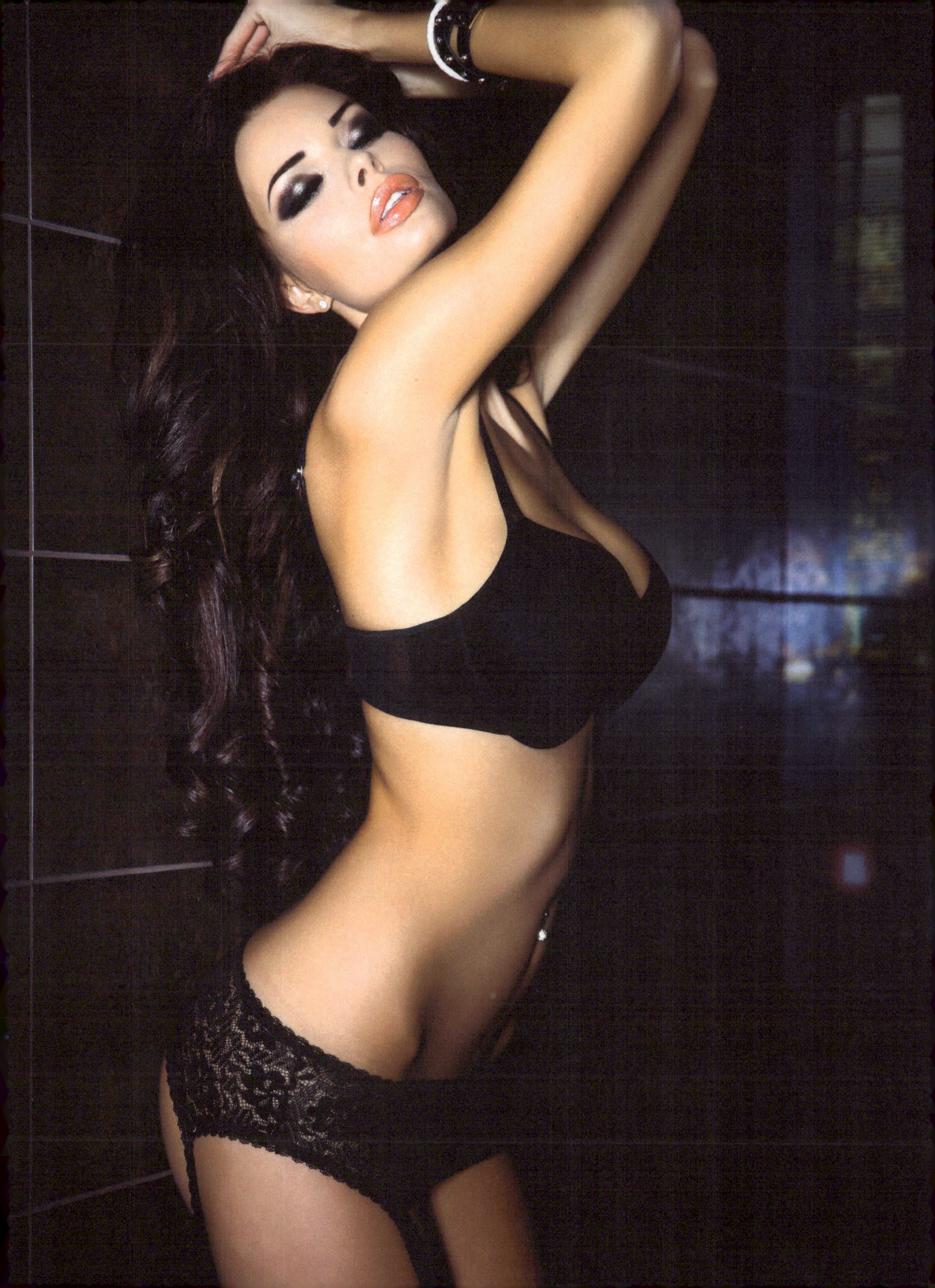

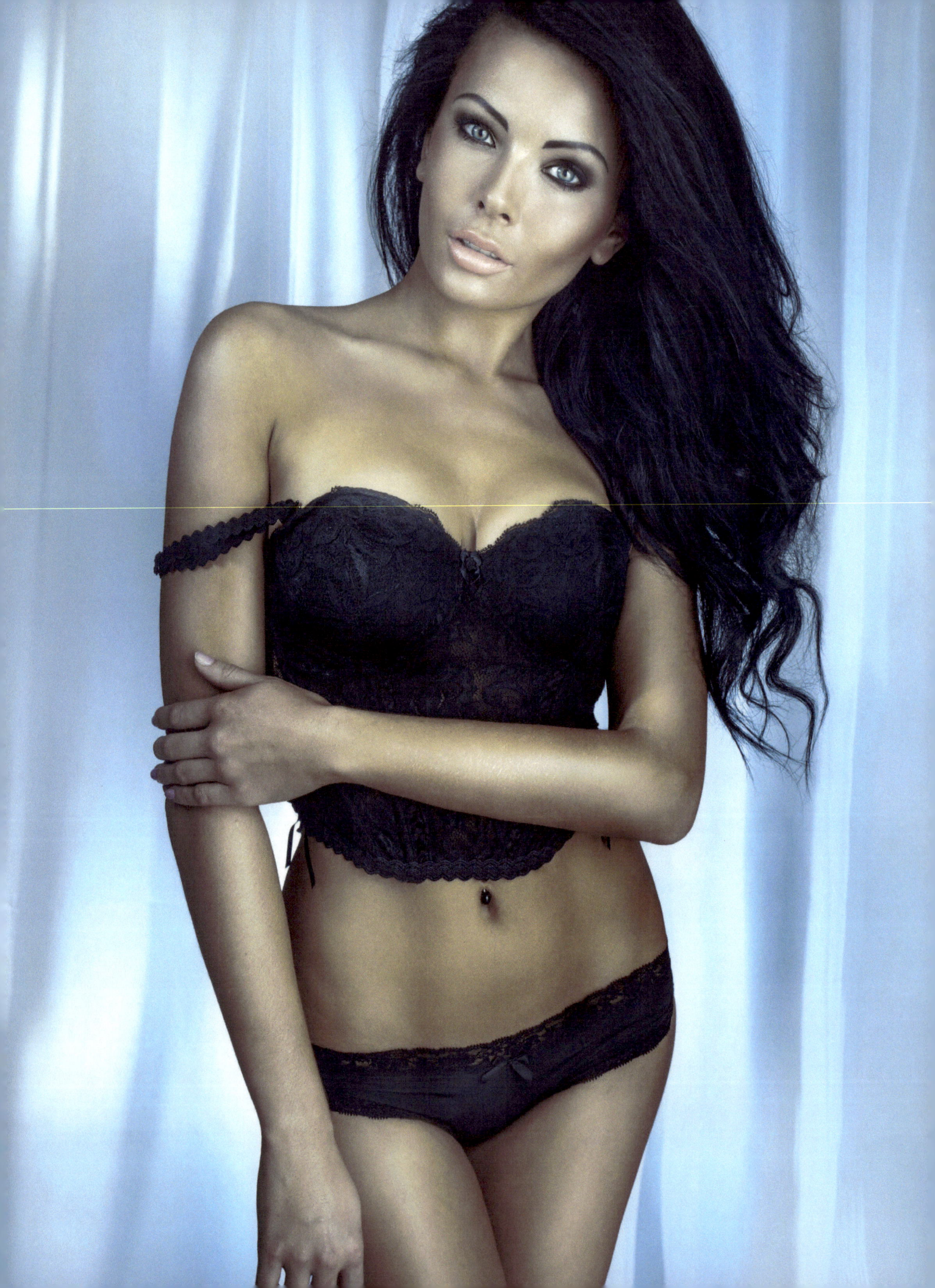

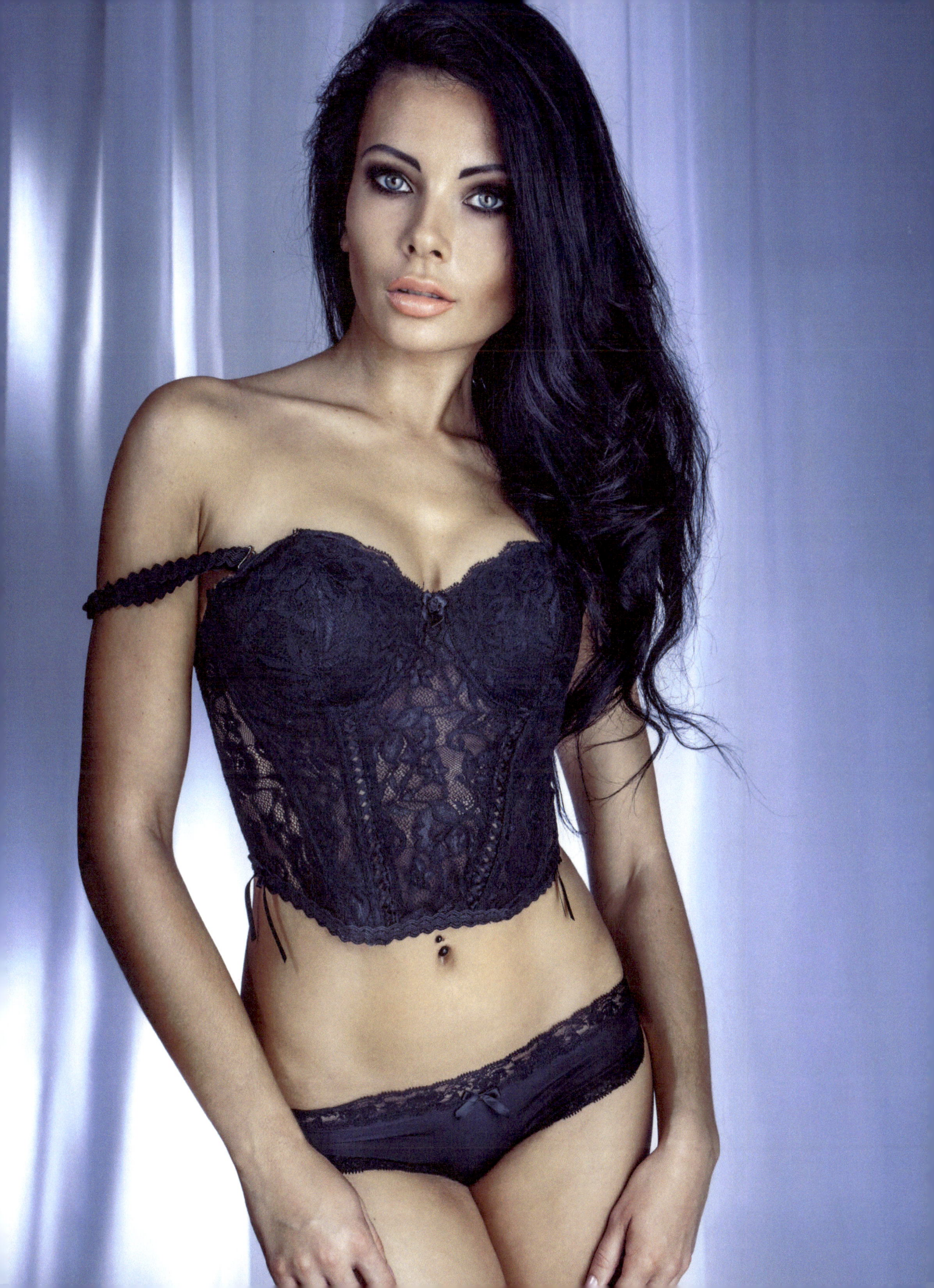

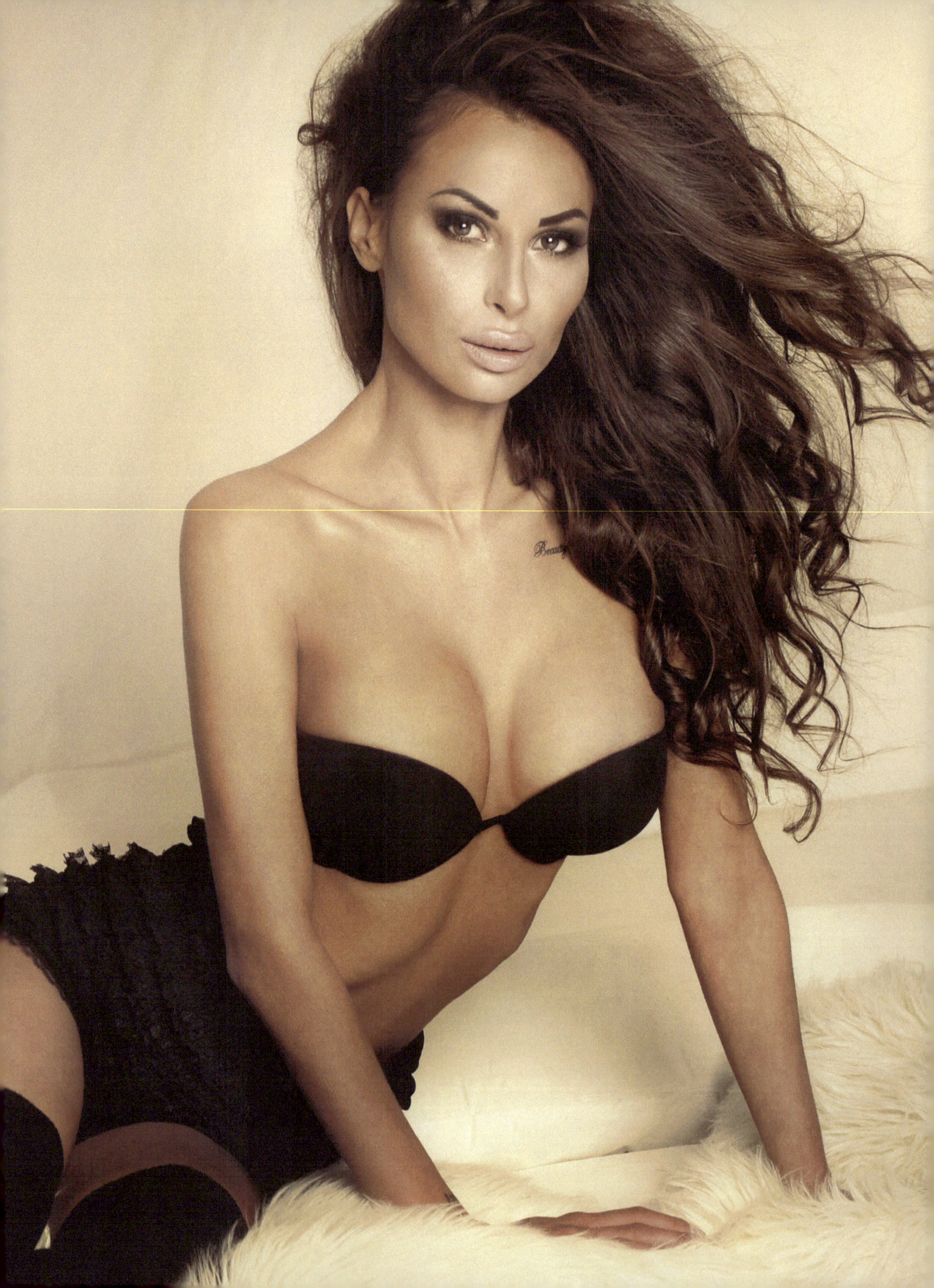

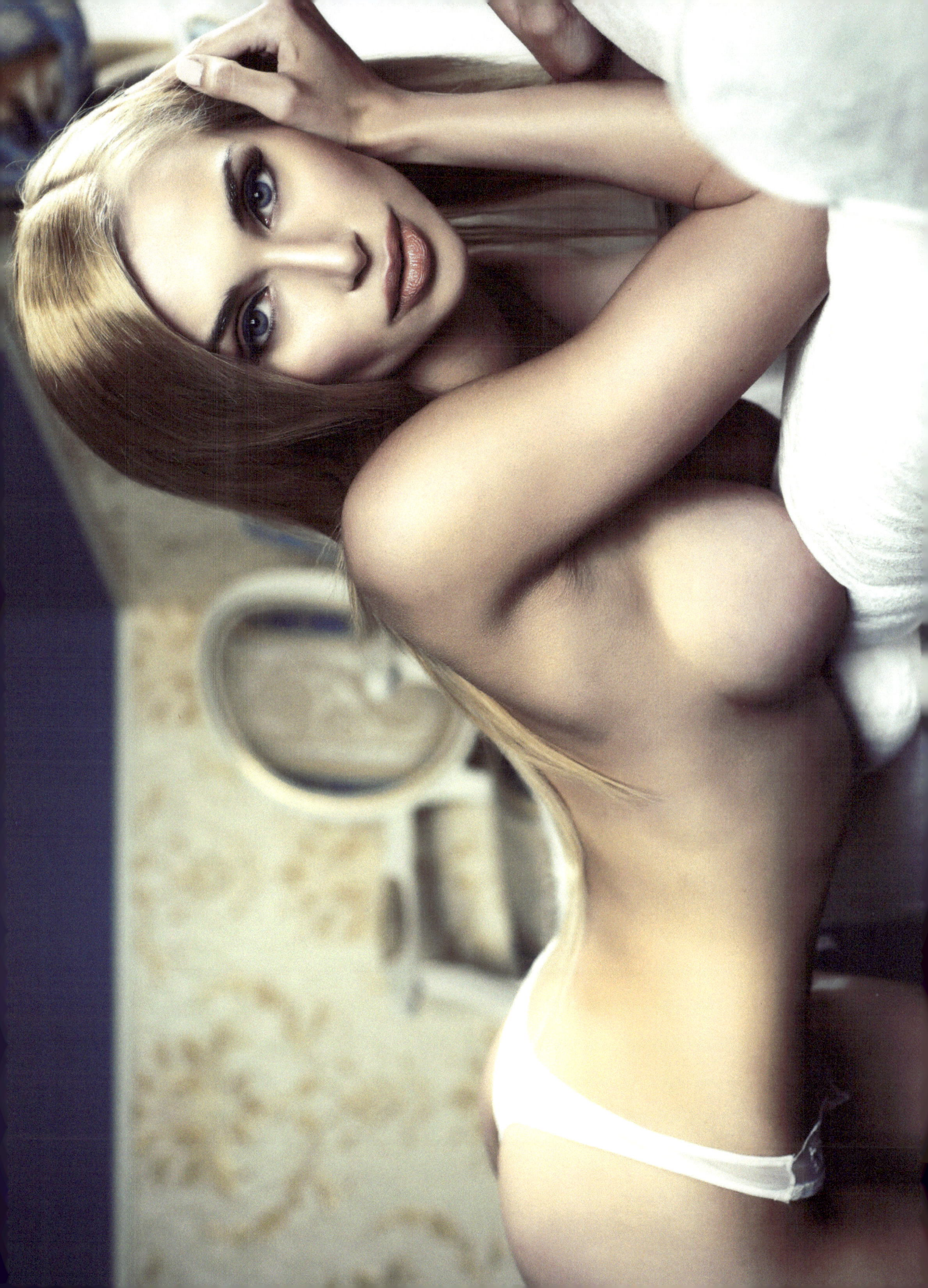

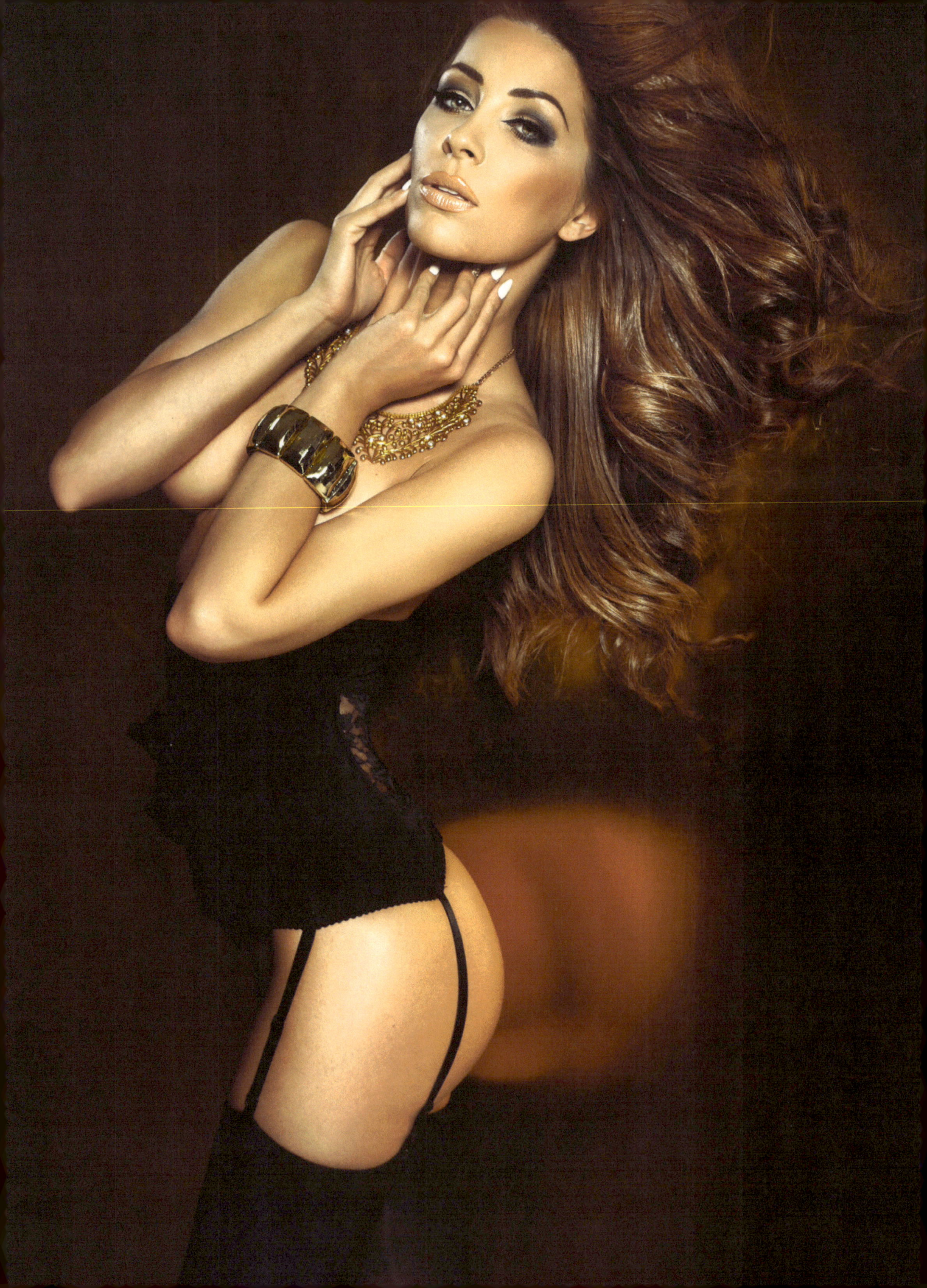

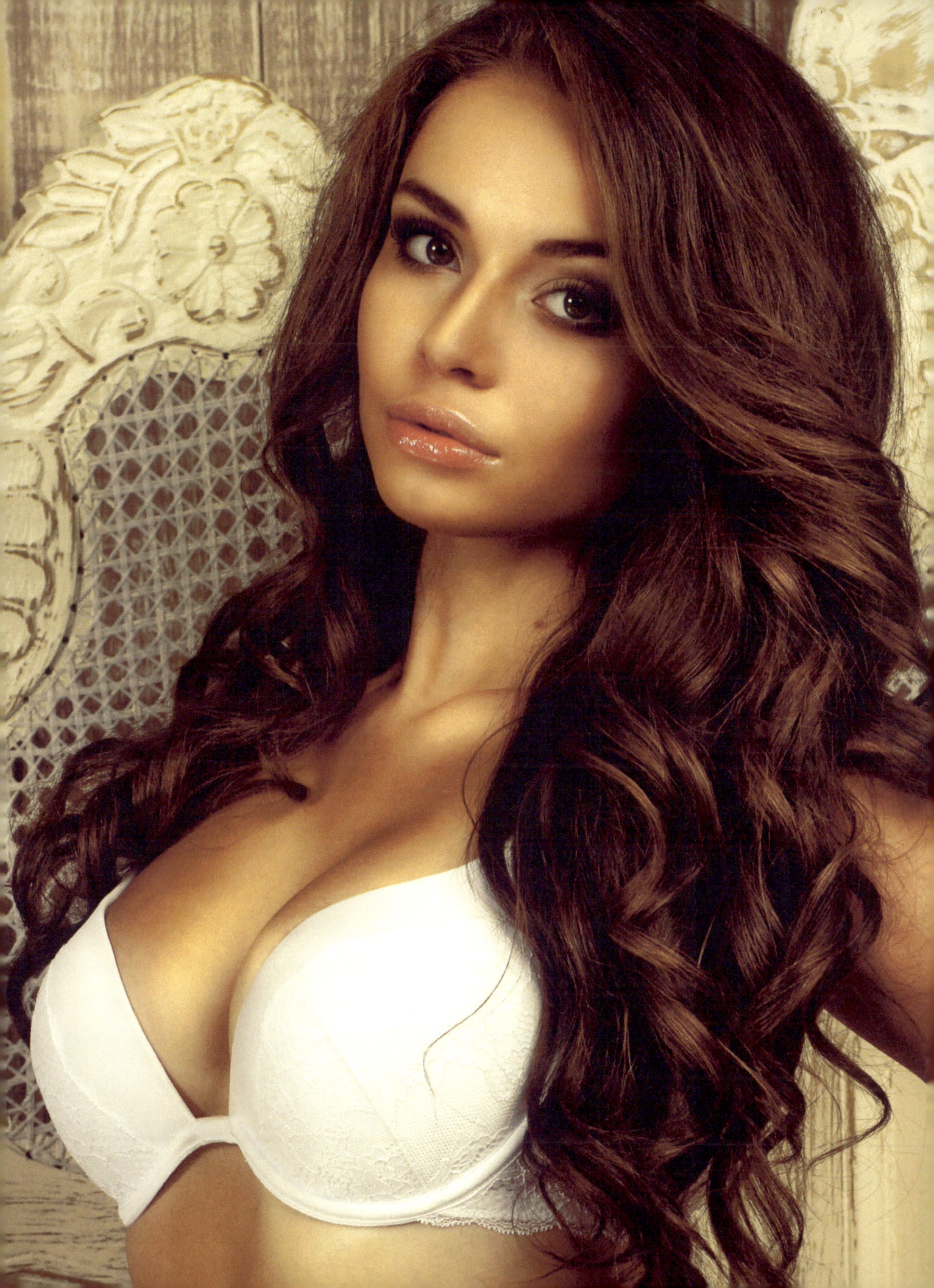

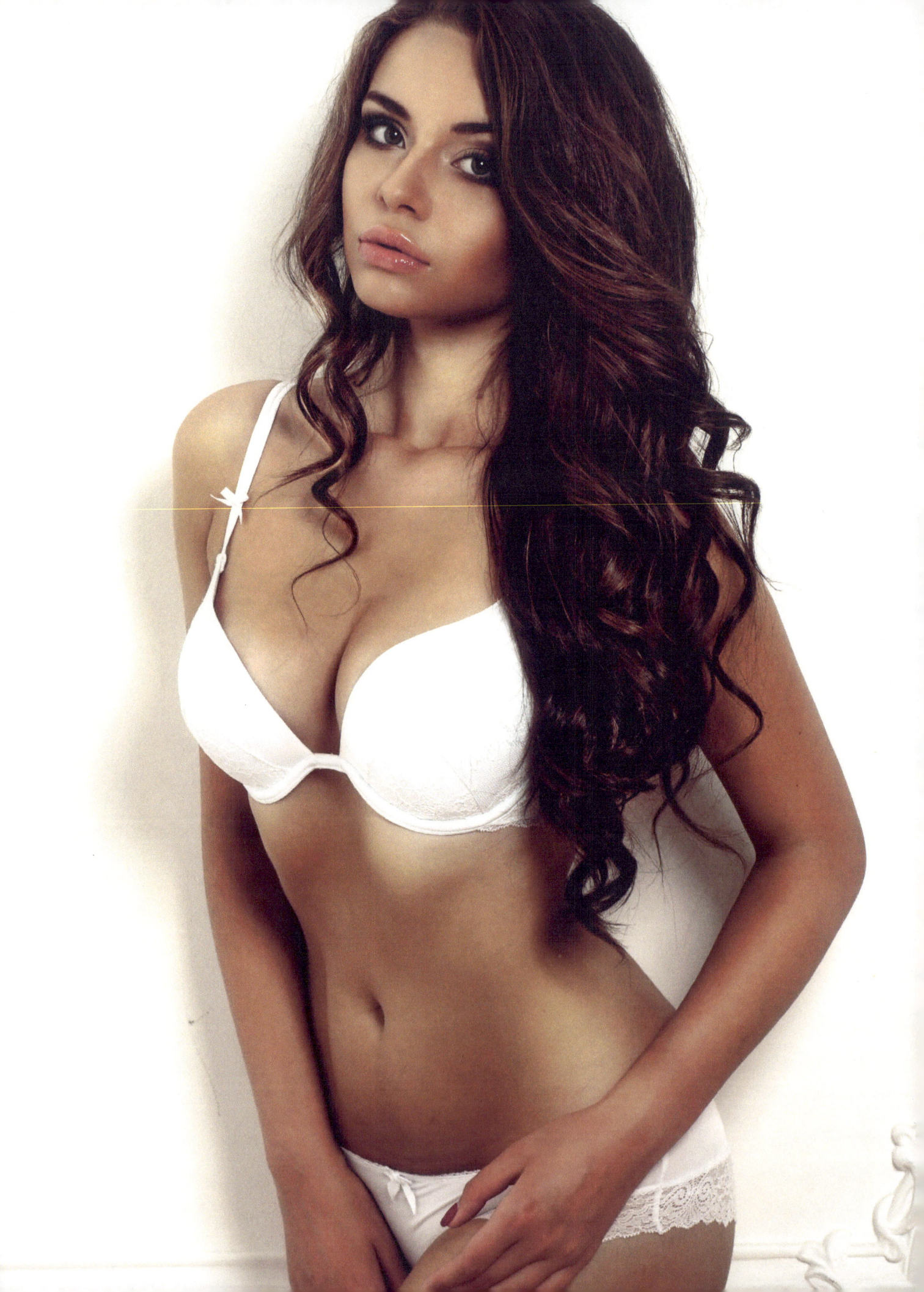

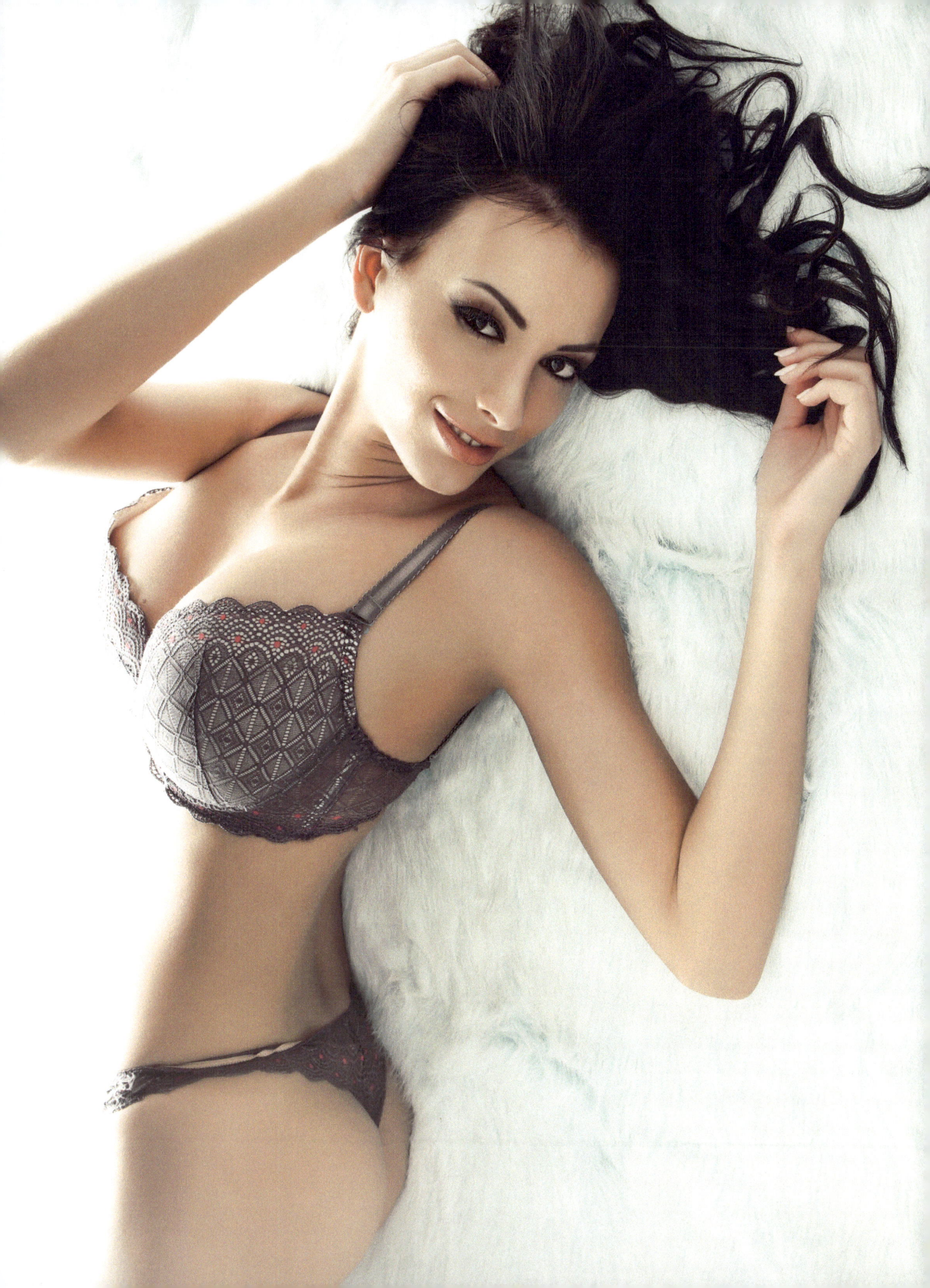

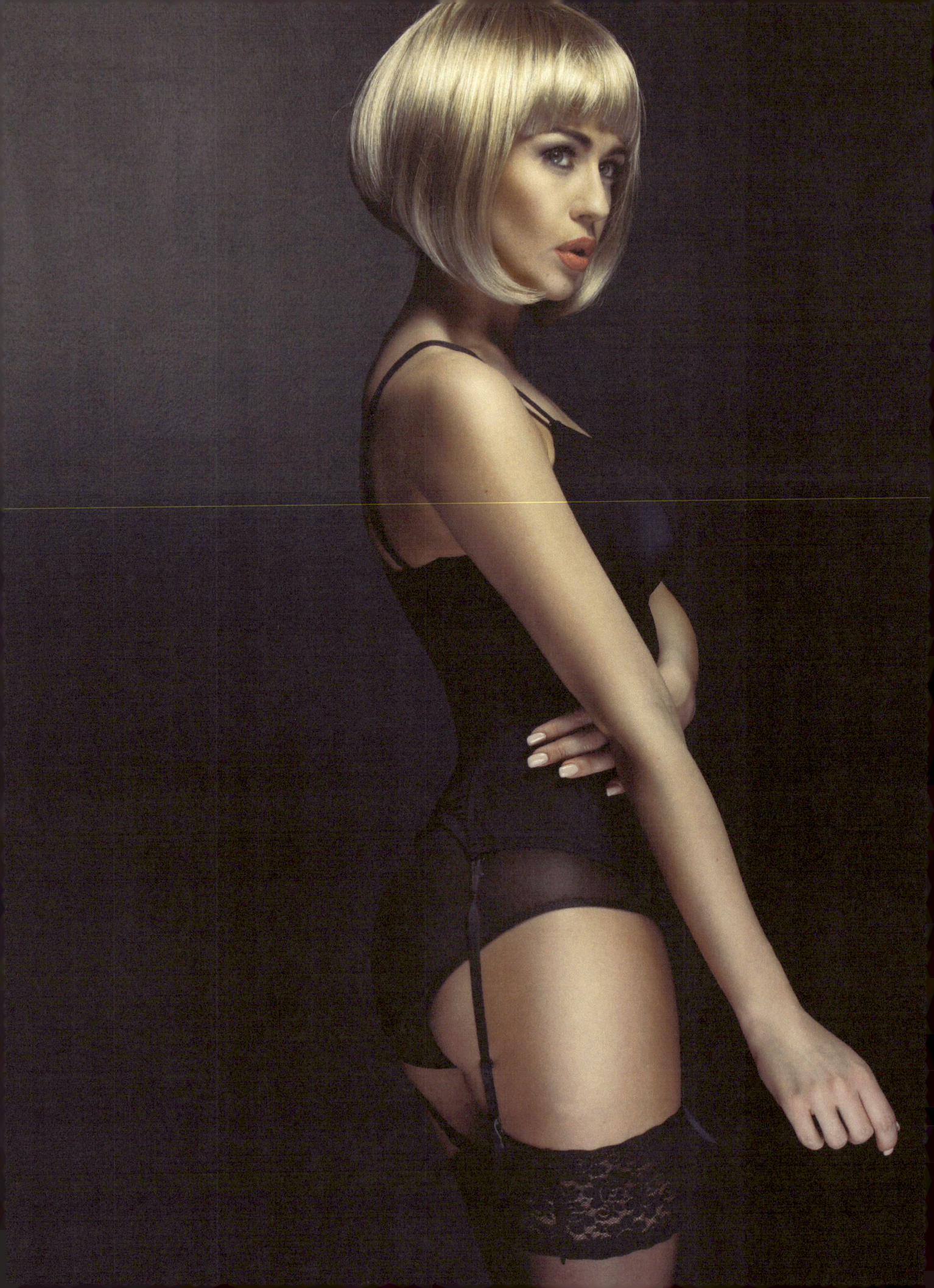

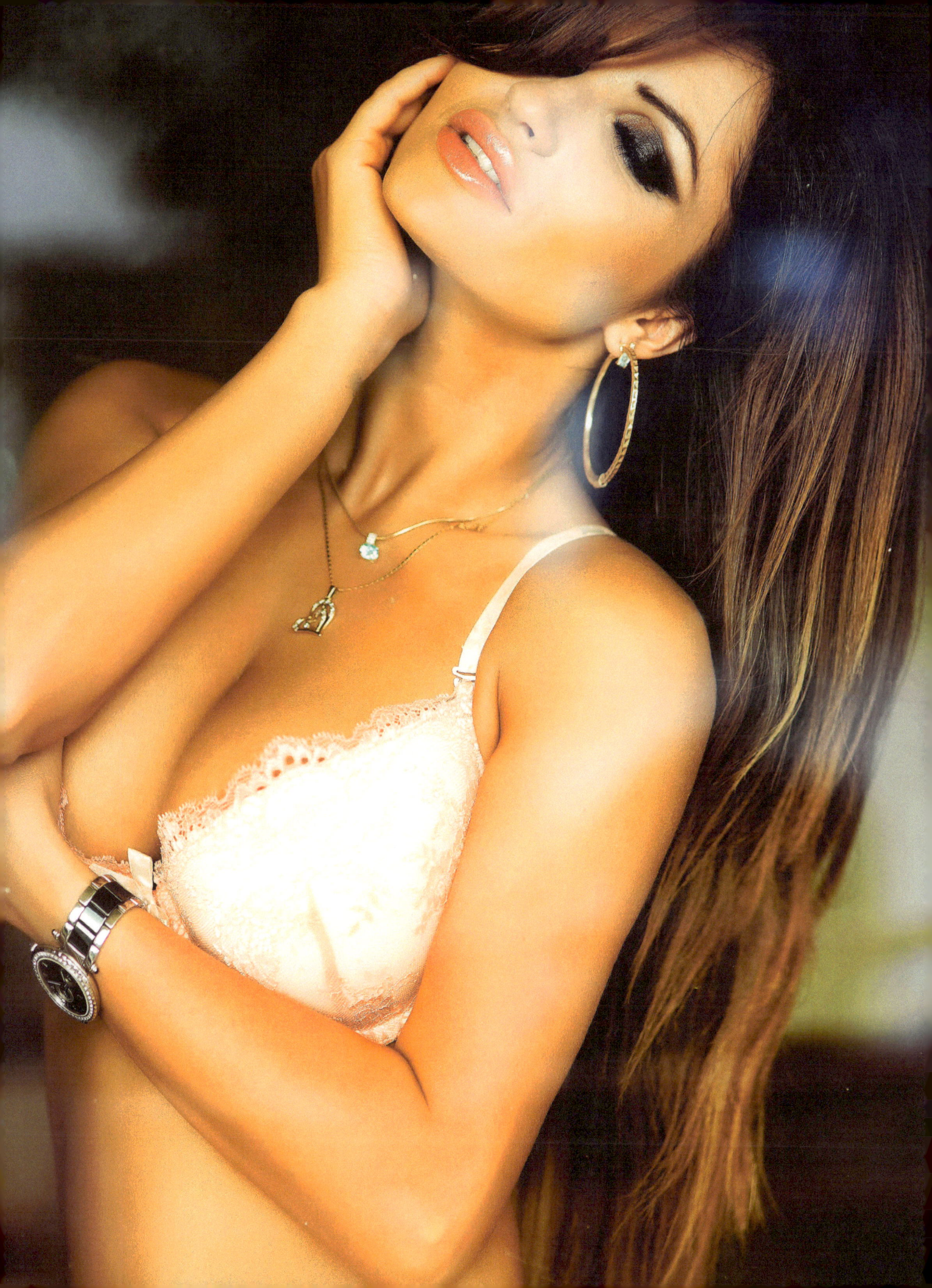

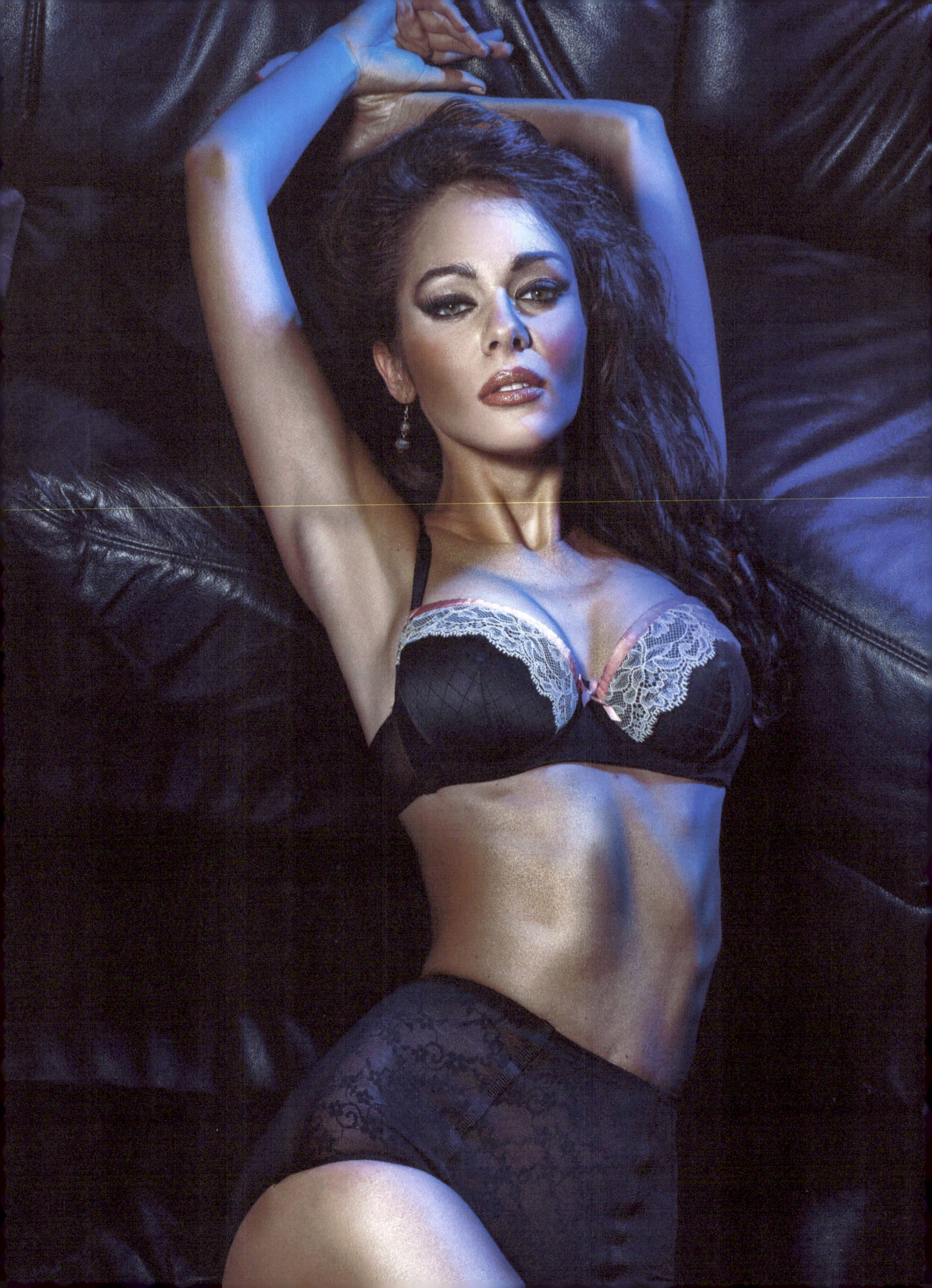

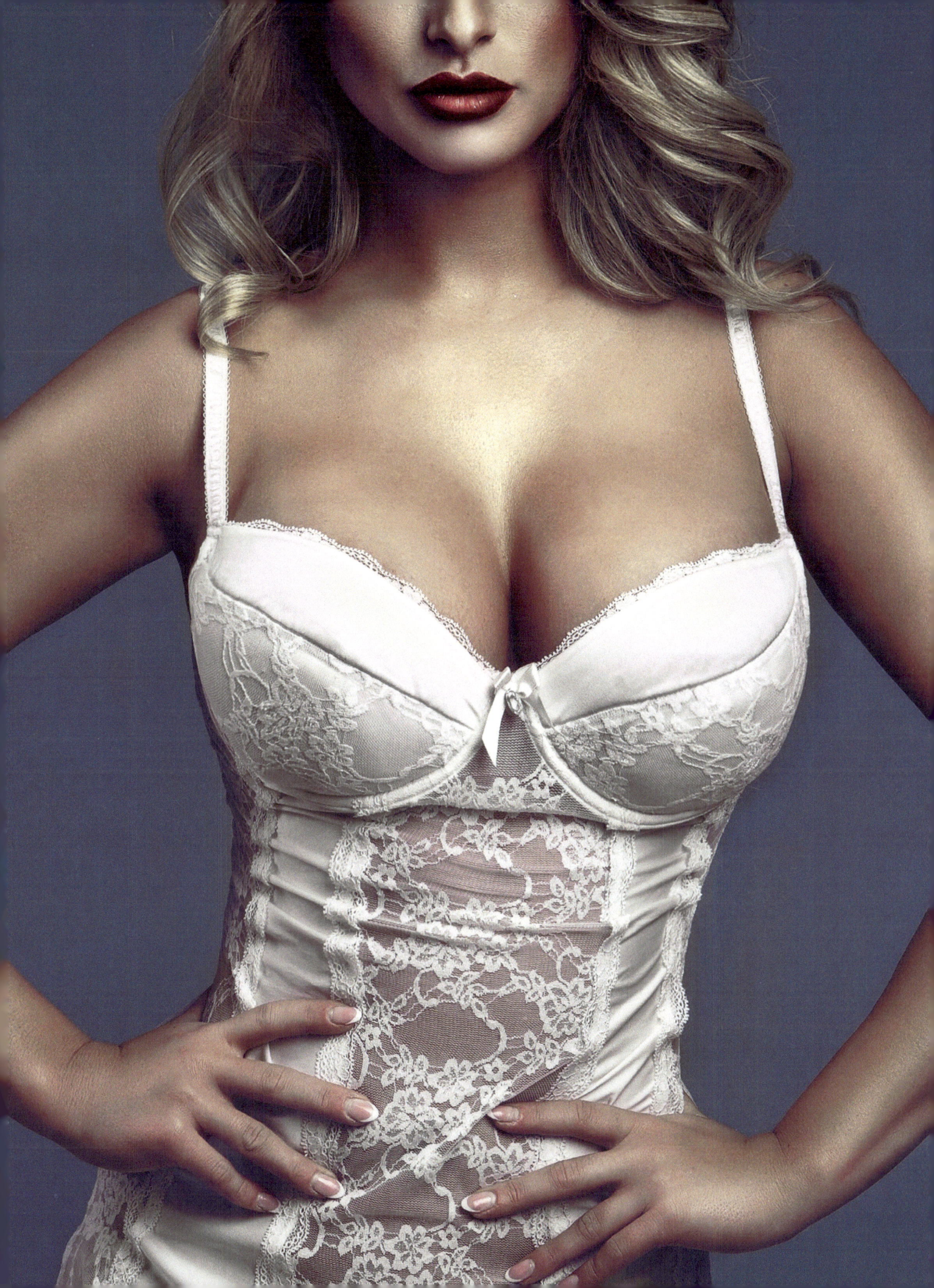